D1397028

IMAGES
of America

HUDSON

OHIO

To John Harney,
Jane Ann Turzillo
12/02

For my son, John-Paul Paxton, who is a great source of love, encouragement, entertainment, and pride.

IMAGES
of America

HUDSON
OHIO

Jane Ann Turzillo

ARCADIA

Copyright © 2002 by Jane Ann Turzillo.
ISBN 0-7385-2004-7

Published by Arcadia Publishing,
an imprint of Tempus Publishing, Inc.
3047 N. Lincoln Ave., Suite 410
Chicago, IL 60657

Printed in Great Britain.

Library of Congress Catalog Card Number: Applied For.

For all general information contact Arcadia Publishing at:
Telephone 843-853-2070
Fax 843-853-0044
E-Mail sales@arcadiapublishing.com

For customer service and orders:
Toll-Free 1-888-313-2665

Visit us on the internet at http://www.arcadiapublishing.com

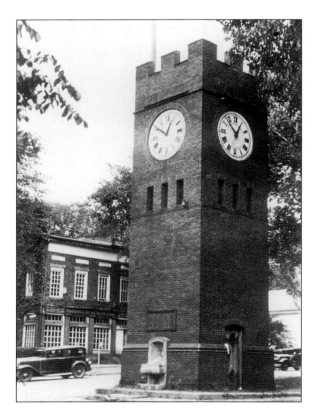

The Clock Tower is the symbol of Hudson. Shown here from the southwest, it sits on the corner of Main and Aurora Streets. James W. Ellsworth built it in 1912 as a gift to the people of Hudson. It still tolls on the hour. The Brewster Store is in the background.

CONTENTS

Acknowledgments 6

Introduction 7

1. Beginnings 9

2. Faith and Education 29

3. The Abolitionists 43

4. Western Reserve College 55

5. Main Street 65

6. Everyday 89

7. Ellsworth 103

8. Changes 111

ACKNOWLEDGMENTS

Hudson's history is so rich and important to the Western Reserve that no one book could tell the whole story. This book is but a small representation of the brave, forward-thinking men and women who cast out into the unknown to settle Hudson and build it into the vibrant community it is today.

All of the photographs printed here are used courtesy of the Hudson Library and Historical Society. The images span the time period of 1799 to 1958. Every effort was made to represent all of the people, buildings, and events of historical significance.

I could never have put this book together without the cooperation of a number of people. My first thanks goes to Ron Antonucci, Assistant Director of the Hudson Library and Historical Society, for opening the doors to the archives. He put me in the capable hands of Head Archivist James F. Caccamo and Assistant Archivist Gwendolyn Mayer. Jim was generous with his time and considerable knowledge of Hudson history. He not only pulled photographs from the files and patiently answered my long lists of questions, but he proofread the final manuscript. Gwen spent hours pulling photographs and discussing them with me. Her suggestions were of great value to me. Sincerest thanks to both of them.

Many thanks to Dan Liddle of Quick Photo, who came through for me by making excellent scans and copies of the images. His talents can't be measured.

Two people who are always there for me during my projects, both of them fine writers, are my sister, Mary Turzillo, and my good friend, Marilyn Seguin. Their encouragement is deeply appreciated.

During my research, I had the pleasure of reading works by the following authors: General Lucius V. Bierce, James F. Caccamo, Lora Case, Patricia Eldredge and Priscilla Graham, the Hudson Heritage Association, the Hudson Library and Historical Society, the 140 Hudson Local School Eighth Graders of 1983 through 1989 and 1997, Grace Goulder Izant, Alice Johnson, Samuel Lane, William Henry Perrin, J.F. Waring, and the Christ Episcopal Church Women's Guild.

Again, to all who helped, my heartfelt thanks.
Jane Ann Turzillo
Bath, 2002

INTRODUCTION

The history of Hudson began when King Charles II of England granted the colony of Connecticut a 120-mile strip of wilderness in what is now Northeast Ohio. This untamed territory became known as the Connecticut Western Reserve. In 1795, the Connecticut Land Company began to sell 25-mile-square parcels of this land through a lottery. David Hudson and five partners anted up $12,900 for Township 4 Range 10.

Hudson was the only one of these partners to set out into the wild to claim his territory. The trip took two months through the unfamiliar lands of New York and over the ice-filled waters of Lakes Ontario and Erie. On June 26, 1799, he and his small party landed in the Western Reserve. Several months later, Hudson returned to Connecticut to bring back his family and other pioneers.

This collection of more than 200 vintage photographs belonging to the Hudson Library and Historical Society chronicles the settlement and growth of Hudson, Ohio. The story begins with David Hudson and moves forward to the establishment of churches, schools, businesses, and a college. In 1826, Western Reserve College opened it doors to educate young men. Known as "the Yale of the West," it was one of the only schools of higher learning in the West and employed top teachers from the East. The fiery John Brown figures prominently in the history of Hudson, as do other abolitionists and participants in the Underground Railroad. Hudson flourished economically and socially until a series of misfortunes took their toll. In 1856, plans for the new Clinton Air Line Railroad collapsed, bankrupting citizens and businesses. Western Reserve College relocated to Cleveland in 1882. The Fire of 1892 destroyed an entire block of businesses along Main Street, and the only bank in town suddenly closed its doors in 1904, leaving many Hudson residents without their life's savings.

In 1907, native-son James W. Ellsworth returned to Hudson after making a fortune in the coal industry. Saddened by the deterioration of his hometown, he outlined a plan to restore Hudson as a "model town" and vibrant community. In return, he asked council to close all the saloons and drinking establishments. Putting his vast financial resources and initiative to work, he paved the muddy roads, installed sewer and water systems, brought electricity in, buried phone wires, established reliable banking, and opened the Western Reserve Academy on the old college grounds. Hudson has continued to thrive after Ellsworth's intervention.

These photographs come from the archives of the Hudson Library and Historical Society. They take the reader from 1799 to 1958 by way of images of the Brown family, polar explorer Lincoln Ellsworth, the Brewster Store (the commercial building longest in use in the Western Reserve), Hudson House (oldest house in Summit County, built in 1806), and the Loomis Observatory (first observatory west of the Alleghenies). Many photographs show the spectacular architecture of homes and businesses. Throughout this historical journey, these images tell the stories of men and women of great vision.

One
BEGINNINGS

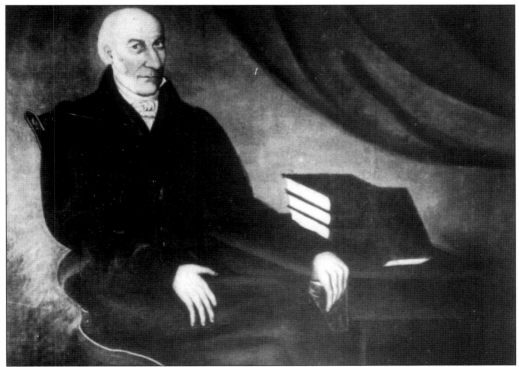

In January 1798, David Hudson (1761–1836) of Goshen, Connecticut, and five other men participated in a land lottery and bought 16,000 acres from the Connecticut Land Company in the Connecticut Western Reserve (Ohio). Of the six who shared the expense for the land, only Hudson settled in Ohio. On June 26, 1799, he and a small party of seven, which included his son Ira, first set foot on the real estate known as Township 4 Range 10. The first settler in what is now Summit County, he set about building the town which would officially be named Hudson Township in 1802. Deacon Hudson founded his town on the four principals of religion, morality, observance of the law, and education.

On October 28, 1800, Anner Maria Hudson was the first settler's child born in what is now Summit County. The eighth child of Anna Norton and David Hudson, she was named for Anna's mother back in Goshen, Connecticut. Anner Maria was born in the first log cabin built in the county on the corner of Baldwin and North Main Street. She married Harvey Baldwin on October 6, 1817.

The new community's post office was established in 1800 and operated from this desk in David Hudson's cabin. He was postmaster for 29 years.

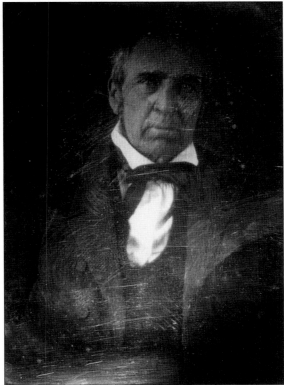

One of the first settlers, Captain Heman Oviatt, shown in this daguerreotype, came to Hudson in 1801 with his wife, Eunice, and two sons. He operated the first store just outside of the settlement, dealing mostly with Indians. In 1802, Hudson became a township, and Oviatt was named one of the trustees. In 1805, he moved his store—which sold whiskey—into town. The village was incorporated in 1837, and Oviatt became the first mayor. He was a founder of the Congregational Church and the Western Reserve College, and deeded 114 acres of his farmland to the college in 1838.

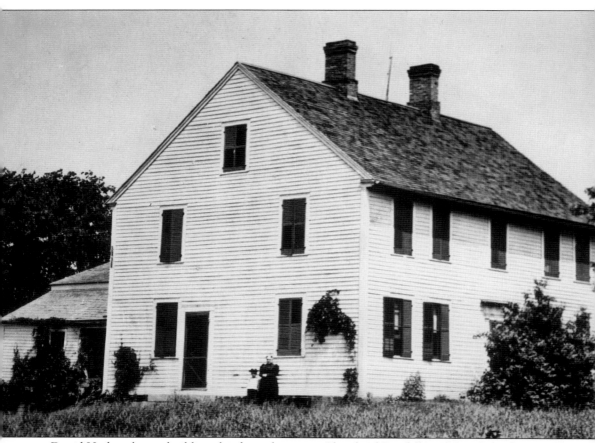

David Hudson began building this frame house on Cleveland Road (later Main Street) in 1805 after his log cabin burned. He selected this land because it had a good spring. The simple "Salt Box" architectural style was reminiscent of houses in Hudson's native Goshen. It stood two stories above the rest of the cabins in Hudson. When finished in 1806, it served as the Hudson family's residence as well as the town hall, church, and inn, until separate buildings could be erected. According to David Hudson Jr.'s diary, the house was also a stop on the Underground Railroad.

Owen Brown (1771–1856) was a friend to David Hudson. Owen, his wife, and five children left Torrington, Connecticut, in 1805 and followed David to the Western Reserve in Ohio. According to Samuel Lane, he was of "direct Mayflower Puritanic decent." A tanner by trade, he became quite wealthy and was one of the largest landowners in Hudson. He shared his famous abolitionist son John Brown's convictions and was himself an outspoken critic of slavery. Although a profound stutterer, he sang and prayed at church with no impediment. The elder Brown was Hudson's first "stationmaster" for the Underground Railroad. He attempted to start the Free (anti-slavery) Congregational Church in Hudson and was a founding trustee of Oberlin College. Ruth Mills Brown was Owen's first wife and John's mother. She died in 1808 giving birth to their eighth child. A few years later, he married Sally Root Brown.

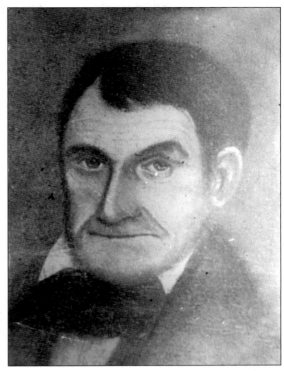

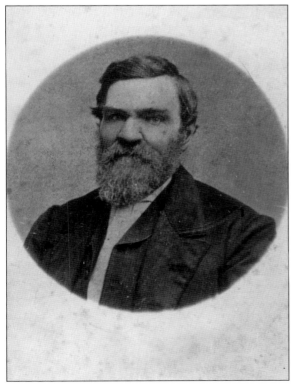

Two-and-a-half-year-old Lora Case came to Hudson in 1814 with his parents, Chauncey and Cleopatra Hayes Case, and his siblings. He described the trip and his life in Hudson in a book, *Hudson of Long Ago: Reminiscences*, which he wrote near the end of his life. The family rode to Hudson in a covered wagon pulled by two horses with a cow hitched to the back. When very young, he became a Sunday school pupil of John Brown's. Case's house near the border of Streetsboro was a stop on the Underground Railroad. He remained an admirer of John Brown throughout the years, and even wrote to him while Brown sat in a jail cell awaiting execution. The last letter John Brown wrote was to Lora Case.

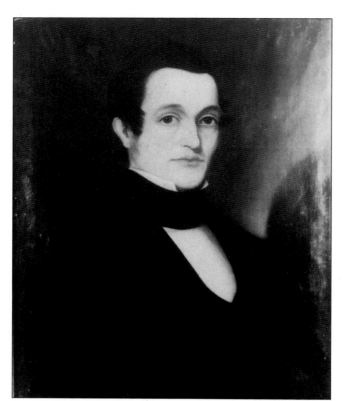

Anson Alvord Brewster Jr. (1807–1864) came to Hudson from Ravenna in 1823 to manage a general store for Zenas Kent. Young Brewster flourished, and in 1839, he built a store on the corner of Aurora and Main Streets. In 1853, he built the sandstone Brewster Mansion between the store and church. His daughter, Ellen, and her husband, D. Duncan Beebe, lived in a house on the east side of the church. The group of buildings became known as Brewster Row. One of the most successful merchants in Hudson, Anson Brewster Jr. served as mayor three times. He died of a heart attack in 1864.

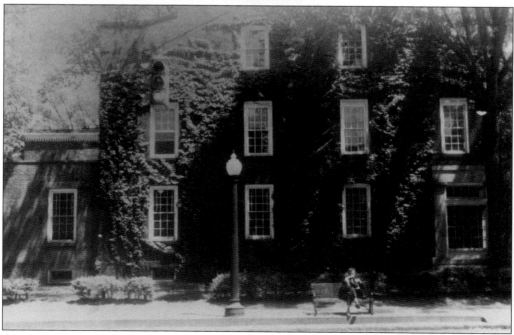

Anson Brewster's store, built in about 1839 on the corner of Main and Aurora Streets, is one of the oldest commercial buildings that has been in continuous use in Summit County.

Sally Porter White of Granville, New York, was in Hudson visiting her sister Lucy Town when she met Anson Brewster, a prosperous merchant. They fell in love and were married by the Western Reserve College president, Reverend Charles B. Storrs, at her sister's house on October 4, 1832. The Brewsters moved into a house built by Owen Brown. The house went up in flames in 1841, and Sally, having just given birth, was carried out on her mattress. Two of her children died of scarlet fever in 1841. Sally died in 1889.

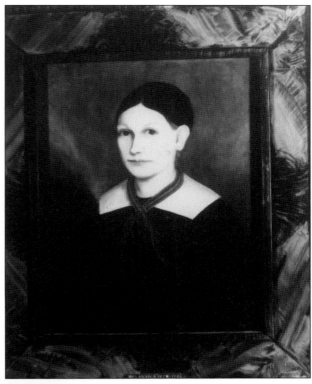

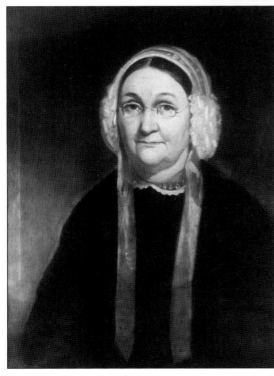

Aurelia Kellogg Brewster, also known as Mrs. Anson Brewster Sr., was the mother of Anson Brewster, Jr.

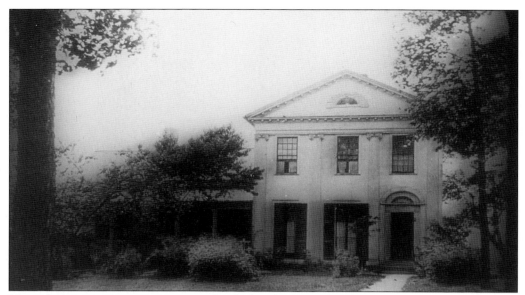

More than one prominent pioneer family has lived in this house on North Main Street. Augustus Baldwin, who came to Hudson with his brothers in 1812, built it in 1825. His father, Stephen, was one of David Hudson's business partners in the original land lottery. John Buss, owner of Buss's general store, became its second owner in about 1890. In 1927, Charles Merino moved in.

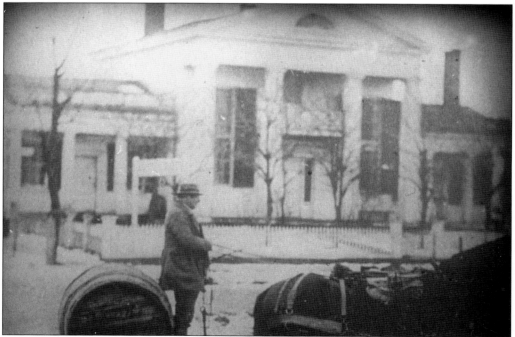

As one of the earliest doctors in Hudson, Israel Town treated both David Hudson and Harvey Baldwin. The camera peeks at Israel Town's house behind a horse and cart. This photograph shows the house as it was originally built in 1835, with a wing on each side.

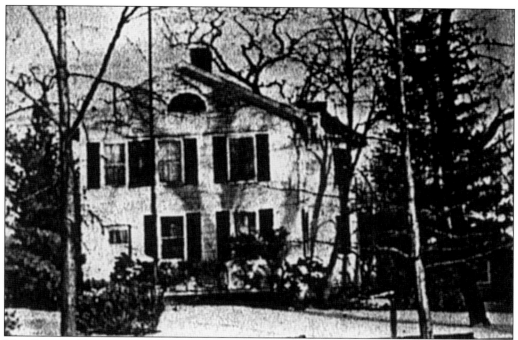

The Captain Heman Oviatt house on East Main Street was probably built in 1825.

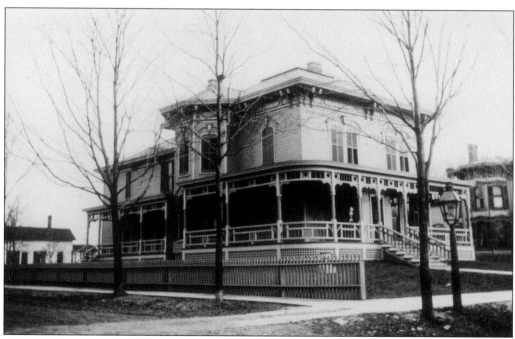

Dr. Israel Town was the brother-in-law of Anson Brewster and a founder of the Christ Episcopal Church. At the time he lived in this house, it had a wing on each side. The wings were removed in the late 1800s and the façade was changed. One of the detached wings became a separate residence.

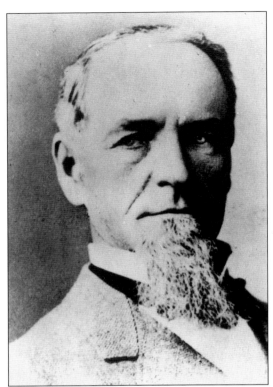

Timothy Hudson Jr. was one of David Hudson's sons. At one time, he was the treasurer of Western Reserve College and a strong abolitionist. He managed one of his father's farms in Wadsworth. Upon his father's death, he and his brothers William and Milo inherited equal shares of land holdings in Medina and Geauga counties.

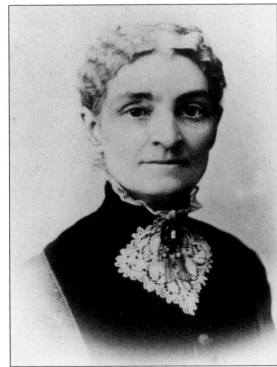

Although Anna Wolcott was married to Timothy Hudson Jr., she never lived in Hudson.

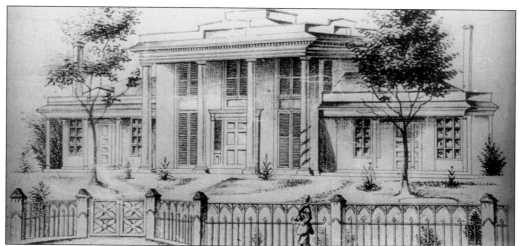

Built in 1836, this house was as imposing as its owner Van Rensslaer Humphrey (1800–1864) was. A large man in stature, the impressive Humphrey was elected to the State Legislature in 1828 and reelected in 1829. In 1837, he began a seven-year term as a judge. He served as defense council during the first murder case in Hudson, which occurred in 1860. He was known for his temper outbursts. One story has it that he smashed a newspaper press so it couldn't print an article on abolitionism. Humphrey died of apoplexy.

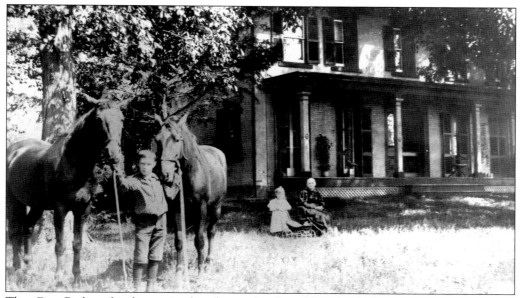

The Case-Barlow farmhouse is thought to be the oldest brick house west of Pittsburgh, Pennsylvania. Chauncey Case built the house between 1826 and 1833 from brick made in a kiln on his farm. He and his family lived in a log cabin on the property while he fired the bricks. One of his descendants, Henry C. Barlow, lived on and worked the farm while he was mayor of Hudson from 1946 to 1957. The house stayed in the family through five generations. Now in the hands of the Case-Barlow Farm, Inc., a non-profit organization, it is being restored. A 60-acre park surrounds it. This photograph is labeled as taken between 1880 and 1890. The people are identified, from left to right, as Henry Barlow, Clara May Barlow, and Mrs. Henry "Grandma" Case.

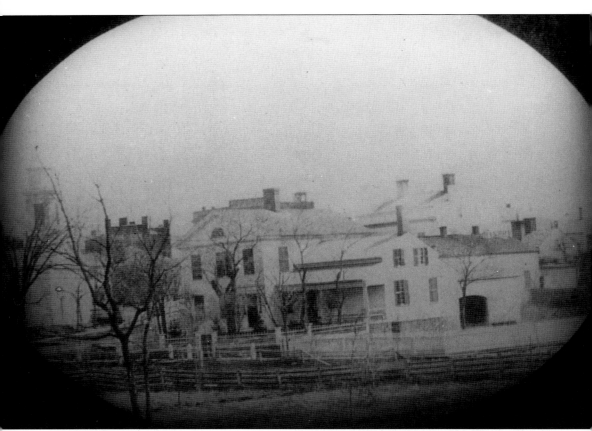

This is the Frederick Baldwin House, built in 1834. The photograph was taken during the early 1860s. Baldwin's only daughter, Caroline, was born in this house. Today we know it as the Hudson Library and Historical Society. Funds left at Caroline's death allowed the library to purchase the house in 1924.

Salome Bronson [Brownson] Baldwin, from Winchester, Connecticut, married Frederick Baldwin February 12, 1828. Frederick and his brother Augustus came to Hudson in 1812 with a wagon full of goods. They opened the second store in the township, A. Baldwin & Brother, which later became Buss's general store. In 1844, Frederick moved his family south of town and went into the cattle business. Salome and Frederick had two daughters, but only Caroline lived. Frederick died July 7, 1880. Salome followed May 16, 1881.

Caroline A. Baldwin, daughter of Frederick and Salome Baldwin, was born December 17, 1841. She married Perry Babcock, who was originally from Ravenna. The Babcocks later moved to Cleveland.

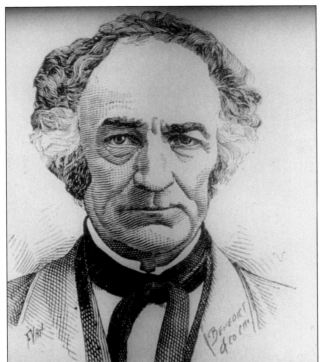

Lawyer Harvey Baldwin (September 17, 1798–June 12, 1880) came to Hudson from Connecticut in 1814. His father, Stephen Baldwin, was one of David Hudson's business partners and an original Hudson land owner. Baldwin married Hudson's daughter Anner Maria in 1817. They lived in the Hudson household most of their married lives. Upon David Hudson's death, Baldwin stepped into the older man's shoes as a town leader. He was a trustee of Western Reserve College and director of the failed Hudson Society for Savings. He and Anner had four daughters.

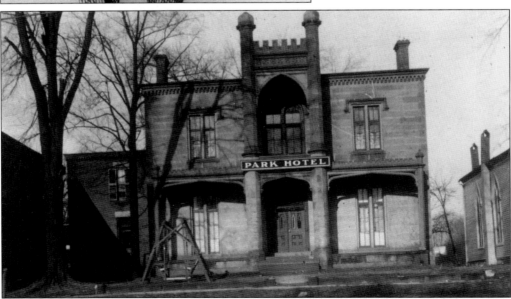

This building was originally Brewster's Mansion and is still known by that name. Built by Anson Brewster in 1853, this sandstone and brick house replaced the Brewster's home that burned down. It is part of Brewster Row and sits on Aurora Street between the Brewster Store and the Christ Episcopal Church. Years later, it became the Park Hotel, owned by Minnie Moran. The building then sat vacant for several years before it became a rest home. It was restored in 1982.

In her younger years, Anner Maria Hudson Baldwin was a great help to her father, David, by managing the bar in her father's tavern and inn. David opened the doors to his home for the first tavern and inn in Hudson.

Edgar Birge Ellsworth (1815–1883) spent a good deal of his life in a wheelchair due to an infection in his leg that didn't heal. The leg was finally amputated, but the handicap did not stop him in business dealings. In 1841, he built Ellsworth Store. He and Henry Noble Day were members of the Clinton Railroad consortium. They became partners in the Hudson Planing and Lumber Company, and in 1852 Ellsworth built Turner's Mill. In 1855, he was mayor of Hudson. Married to Mary Dawes Ellsworth, he was the father of James W. Ellsworth and three other sons; Edward, Henry, and Frank.

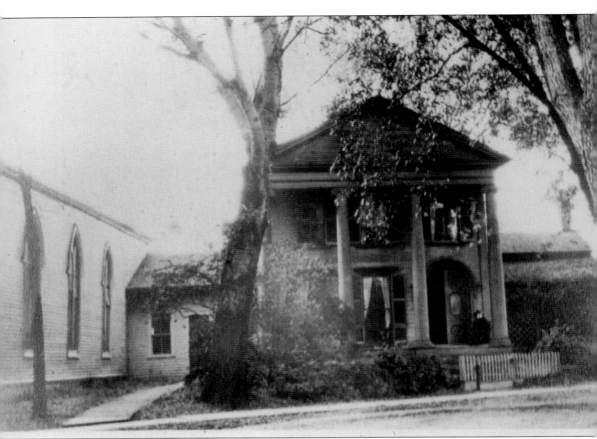

This image of the Isham-Beebe house was taken about 1900, but the house was built in 1834. It was the home of Ellen and Duncan Beebe on Aurora Street. The back of the photograph says the woman is either Ellen Brewster Beebe or her daughter Nellie Beebe (1861–1932).

David Duncan Beebe (1830–1889) was married to Ellen Brewster (1836–1911), daughter of Anson and Sally. The Beebes moved into a grand house on the east side of Christ Episcopal Church on Brewster Row. He served as mayor in 1863. When Anson died in 1864, Beebe took over the family business. In 1867, he was elected State Senator. He was unanimously re-elected in 1879.

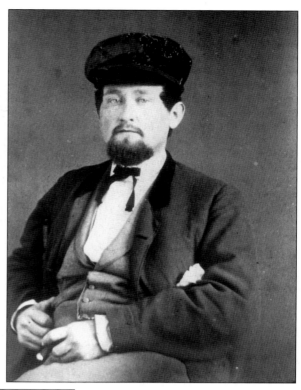

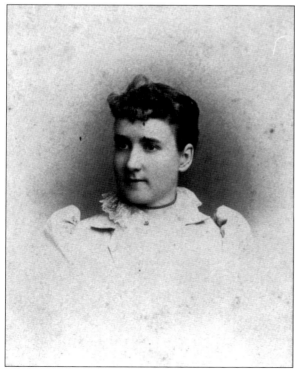

Jessie Beebe Hodge was the daughter of Ellen Brewster and Duncan Beebe and the granddaughter of Anson Brewster Jr.

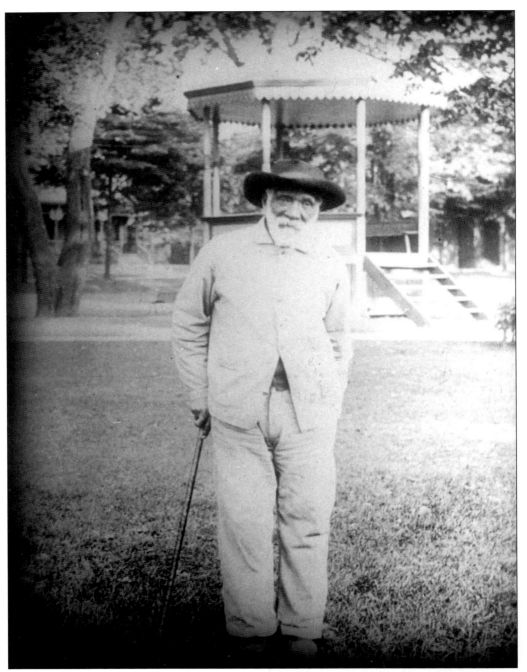

William Branch, shown here in front of the bandstand, was an ex-slave who came to Hudson after the Civil War. He built several houses in Hudson during the 1870s, including one on Owen Brown Street and two on Maple Drive. He fell on hard times in his declining years. In the early 1900s, James W. Ellsworth paid for him to live in a home for aging African-Americans in Cleveland.

David Hudson held his daughter Anner Maria and her husband, Harvey Baldwin, in very high regard and left them his real estate in Hudson. Anner Maria died at 92, a short time before the Fire of 1892 that wiped out most of Main Street.

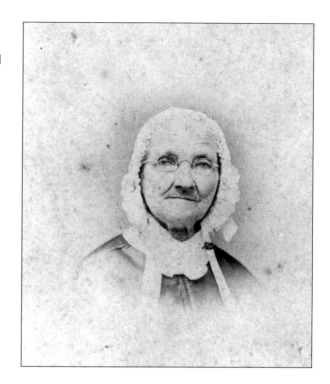

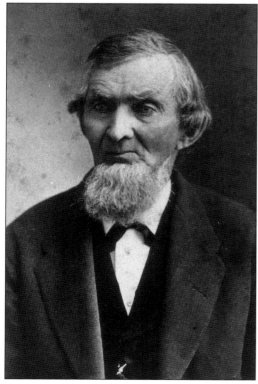

A much older Lora Case wrote *Hudson of Long Ago: Reminiscences* in 1897, the same year he died. The book is a valuable resource to Hudson and John Brown historians.

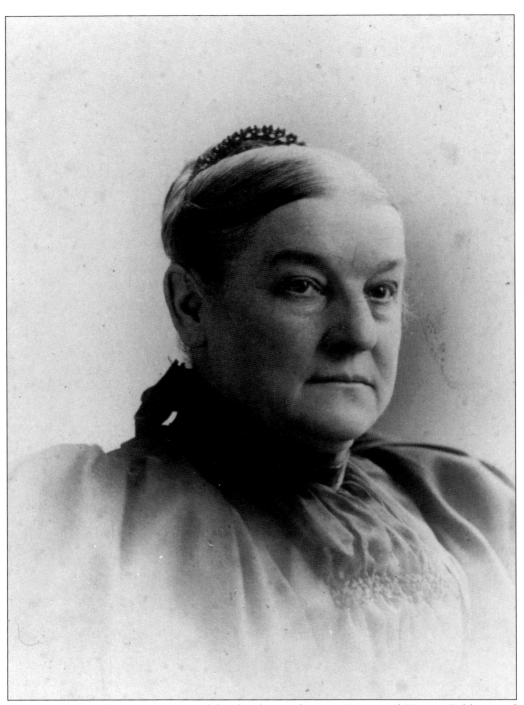

Clarissa Baldwin Gregory was one of the daughters of Anner Maria and Harvey Baldwin and the granddaughter of David Hudson. She married Edwin S. Gregory, a scholar at the preparatory school adjacent to Western Reserve College. They built a house on the Hudson family farm, where she acted as the grande dame of Hudson society.

Two
FAITH AND EDUCATION

One of David Hudson's goals was to "raise an altar to God in the wilderness." Religion was central to the new community of Hudson. David Hudson himself led the prayers of the faithful until 1802. On Saturday, September 4th of that year, Rev. Joseph Badger formally organized the Congregational Church. In 1817, the congregation began soliciting funds for a church building. In 1820, the new church's doors opened for worship at the corner of East Main and Church Streets. The present Congregational Church on Aurora Street was erected at a cost of $10,000. The old church was taken down in 1878.

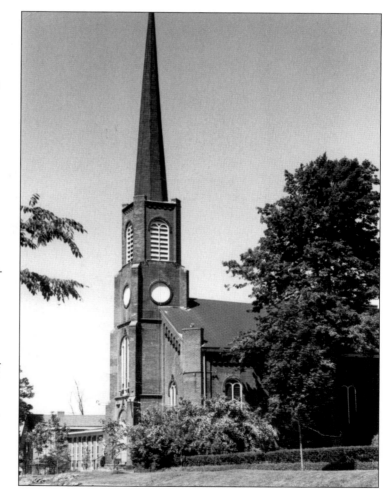

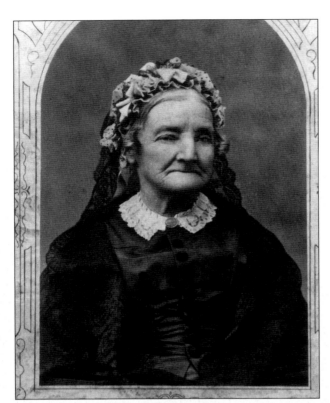

Anner Maria Hudson Baldwin lived her entire life in Hudson. She died at 92.

This photograph was taken Tuesday, October 28, 1890, on the occasion of Anner Maria Hudson Baldwin's 90th birthday. She was the first child born in Hudson. The Congregational Church was festooned with flowers and portraits of Anner (left), her father, David Hudson (center), and her husband, Harvey Baldwin (right). Four hundred people turned out for the celebration.

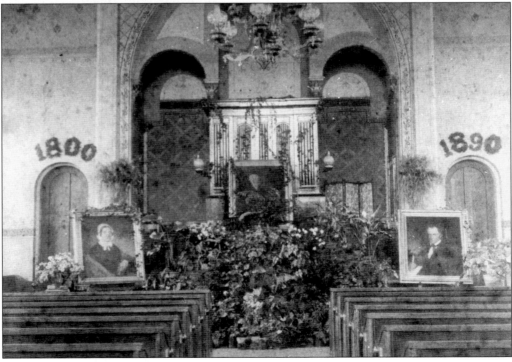

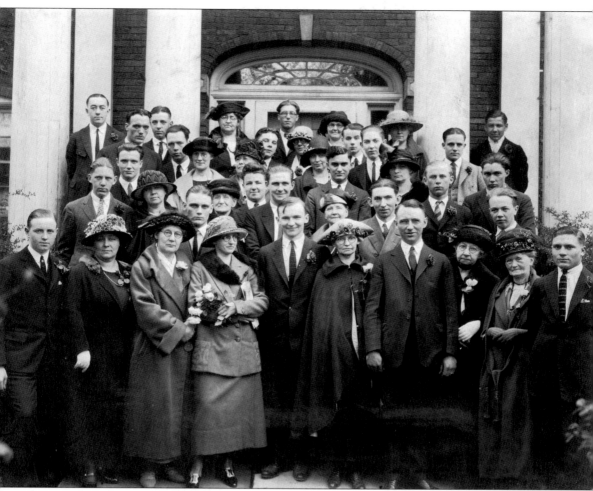

A group from the Congregational Church posed on the steps of the parsonage *c.* 1920.

Anson Brewster, Israel Town, Henry O'Brien, and Frederick Brown formed the first Episcopal Church in Hudson in 1842. Four years later, the first Christ Church Episcopal was built. Brewster installed a clock in the steeple and obtained the bell. In 1930, the church administration had this old church razed. The new Christ Church Episcopal was built that same year on the same site at a cost of $60,000. The original bell, walnut pews, and baptismal were placed in the new church.

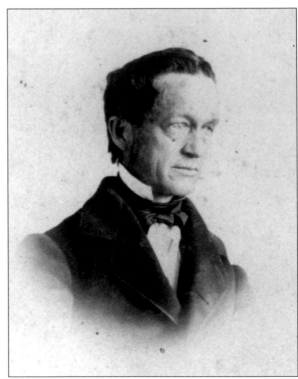

As a founder of the original Christ Church Episcopal, Anson Brewster helped build the church just east of his store on Aurora Street. It was named for Brewster's home church in Hartford, Connecticut.

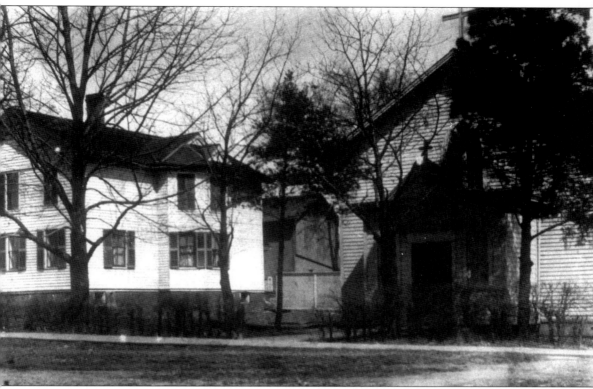

St. Mary's Roman Catholic Church was organized in the 1850s to serve the Irish Catholics who came to build the railroad. Itinerant priests celebrated mass on an occasional basis in temporary quarters near the railroad until the church was erected in 1860. Although there was opposition from some citizens, the small Roman Catholic Church was built at the corner of Oviatt and Railroad (now Maple Street). In 1890, the building was moved to its present location facing the green.

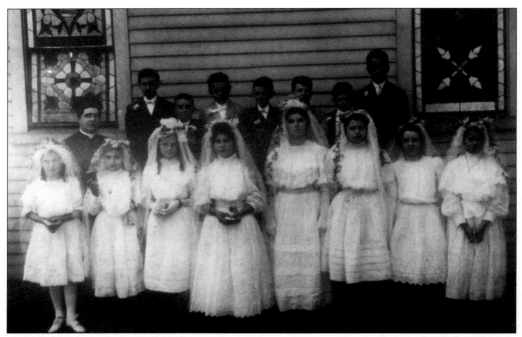

This First Communion class picture was taken at the Old St. Mary's Roman Catholic Church. It is not dated.

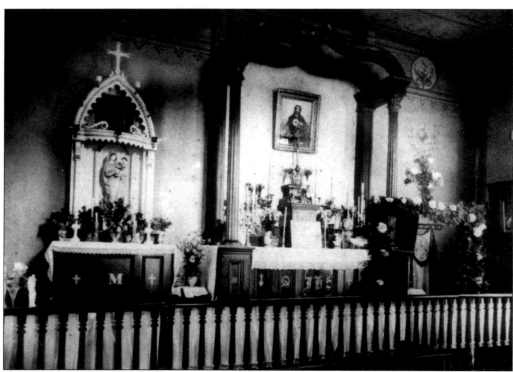

An interior photograph of St. Mary's Roman Catholic Church provides a view of the altar.

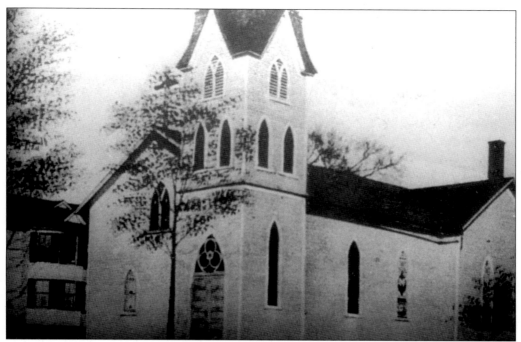

St. Mary's Roman Catholic Church was moved to East Main Street on the green in 1890. Stained-glass windows were installed that year. The steeple, entranceway, and a rear section were added in 1908 and 1909. Parishioners hand-dug a basement under the old section in 1939.

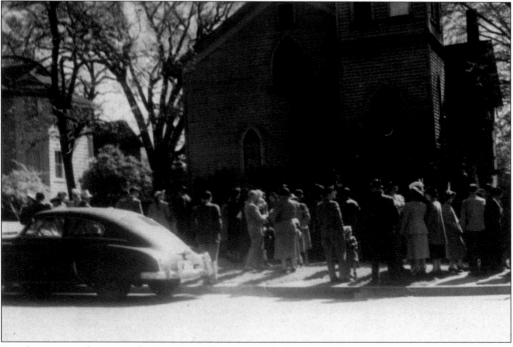

Parishioners gather outside St. Mary's Roman Catholic Church c. 1940.

The Old White Schoolhouse sat at the corner of Chapel and North Main Streets. This one-room district school was built in 1847. Students attended classes here until 1870.

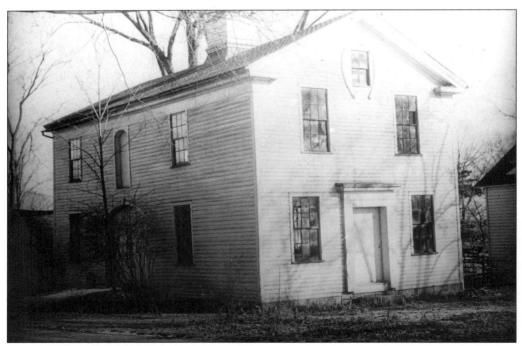

This building was originally a barn built in 1845 on North Main Street. Alice Strong used it as a schoolroom until 1854. In 1858, the building was moved to Baldwin Street where Emily Metcalf ran the Hudson Female Seminary, a successful four-year school for young ladies.

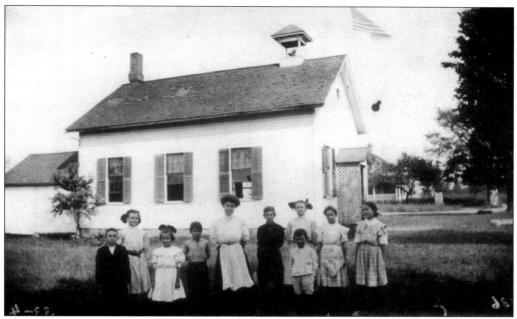

The district schoolhouses were all built to look alike and were all painted white. This one-room district schoolhouse was at the corner of Route 91 and Barlow Road. It was called the Willow Works and later became the Teggart House. It was moved to Hudson Drive in the 1950s.

Miss Emily Metcalf directed a four-year school for young ladies on Baldwin Street from 1858 to 1872.

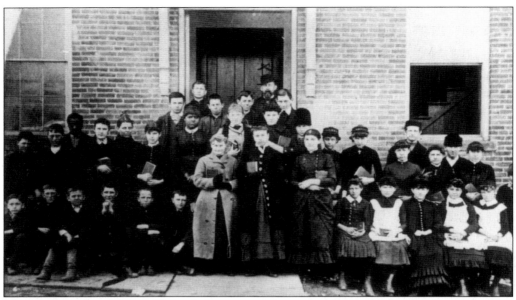

This photograph is labeled, "School class picture. Junior and Senior High School, and A and B Grammer March 1885. A.W. Foster and Anna A. Gross, Teachers."

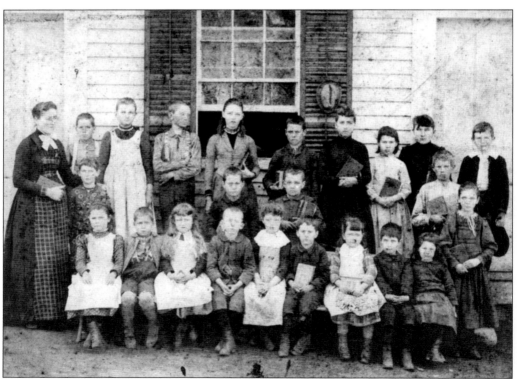

Children posed outside their one-room schoolhouse at Darrowville in 1890. The Jay Collier children are among the youngsters, but not identified.

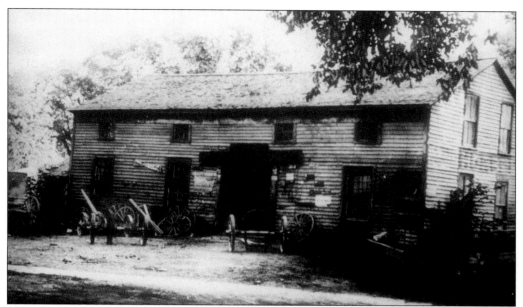

This penny postcard of the Old Seminary is postmarked September 1910. It was sent to Mrs. Hattie Coyle in Sault Saint Marie. The message reads "Dear Ones, Well if you come home a week from Mon, think Oh won't it be great. Mary Myers has got ? fever in Pittsburg (sic) poor girl. School has started again and I am afraid that I am not very glad. with love DLB". The girls' seminary sat where the parking lot of the library is now. It later became Cash's Livery Stable and Blacksmith Shop. It was torn down in 1938.

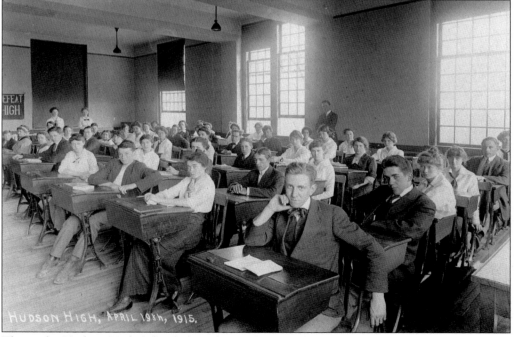

This is the Hudson High School class photo taken April 19, 1915.

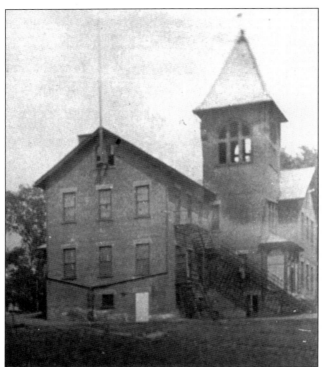

The Union High School was built on the corner of Oviatt and Division Streets in 1868. By 1880, the students of Hudson had outgrown it. In 1886, it was enlarged to accommodate all the village public school children. It was torn down in 1915 to build the Hudson Elementary School.

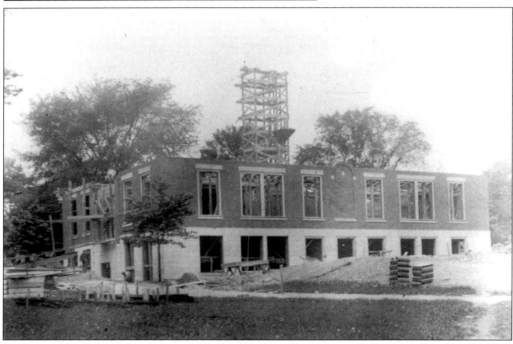

Construction of the original (center part) of Hudson Elementary School, sometimes called the Oviatt Street School, took place in 1916 after the Union High School was torn down. J.W.C. Corbusier was the architect. He worked for James W. Ellsworth.

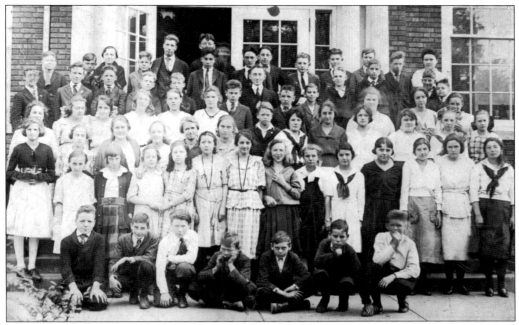

This undated image pictures seventh and eighth graders at Hudson Elementary School. From left to right are the following: (front row) Wallace Croy, Stanton Barns, Edwin Harriman, Sid Eley, Donald Bernitson, Charles Alman, and Clive Kirkhart; (second row) Elizabeth Ryan, Jeanette Scott, Emma Alman, unidentified, unidentified, Ella Wit, Anna Bitner, Mary Capri, Lillian Dubravo, Hildegard Liest, Erma Corbus, Juliana Fitch, and Ruby Wolf. Other names on the back of the photo are: Nellie Litzel, Ione Cary, Katherine Ryan, Ruth Kline, Eleanor Lowman, Phylles Kedgel, Edith Bennett, Ellsworth Long, and Eugene Rideout.

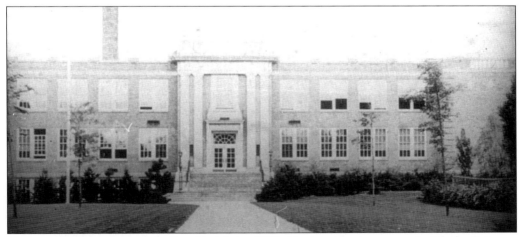

Hudson High School was built of brick in 1927. Students took courses in Math, Science, History, English, Literature, French, Latin, Business, Domestic Arts, Instrumental and Vocal Music, and Physical Education. A narrow black bus took children to and from school. In 1934, the football team won the Summit County championship. By 1935, enrollment in the Hudson Schools was up to 574 students. Female teachers could not be married, and all teachers had to live or board in Hudson.

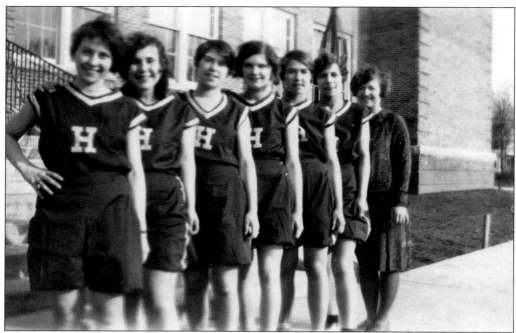

The 1929 girls' basketball team won the Summit County championship. Posing for their photo, from left to right, are Adelaide Rideout, Jeanne Allen, Geraldine Chapman, Dorothy Whitehead, Evelyn Chapman, Ruth Kingzette, and Gwendolyn Drew.

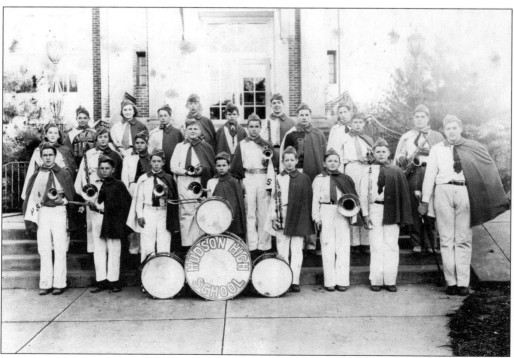

This was the Hudson High School Band *c.* 1940.

Three
THE ABOLITIONISTS

Abolitionist John Brown was born in Torrington, Connecticut, on May 9, 1800. His father, Owen, brought him along with his mother, Ruth, his brothers Oliver and Salmon, his sister, Anna Ruth, and an adopted boy, Levi Blakeslee, to Hudson in 1805. At age 16, John was teaching Sunday school. Sternly religious, he wanted to be a minister of the gospel, but he was unable to keep up with his studies. He became a farmer, tanner, and surveyor instead. Later, he became involved with sheep husbandry and was a fine judge of wool. Dianthe Lusk, whom he married in 1821, died giving birth to their seventh child. His second wife, Mary A. Day, had 13 children.

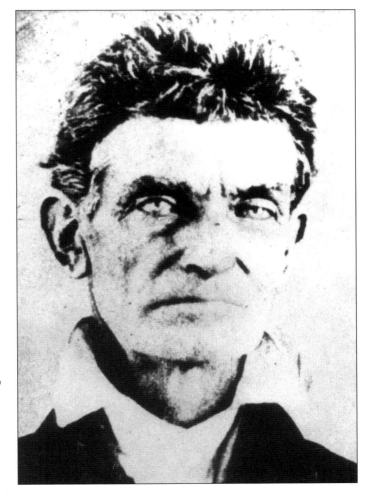

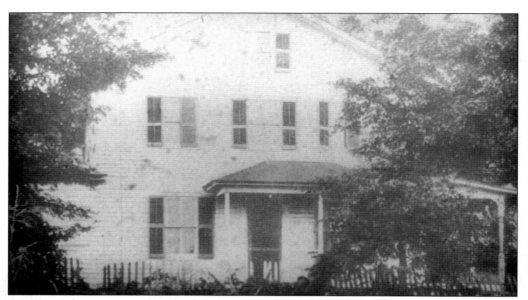

A young John Brown settled back in Hudson after failed attempts to become a minister at Plainfield Academy in Massachusetts and Morris Academy in Connecticut. He built a cabin c. 1819 and founded a tannery. The cabin was later torn down, and this house was built in about 1824. Brown also lived in another house in the northeast corner of Hudson, as well as houses in nearby Akron and Richfield.

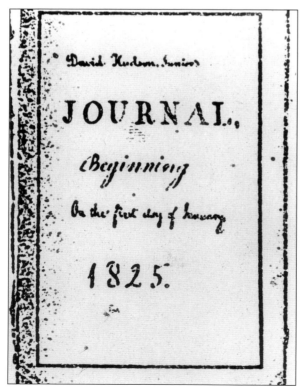

Starting on January 1, 1825, David Hudson Jr. (1805–1836) kept a daily journal for ten years. He referred to it as "a short sketch of my life." It gave insight into the life of a sickly, shy, self-centered young man who worked as a typographer at *The Western Intelligencer* newspaper. The diary also chronicles life in the Hudson household. His father offered him $5 if he would eat three meals a day and wear proper undergarments. His brother-in-law Harvey Baldwin was domineering and made no secret of disliking him. The entry for January 5, 1826 tells of how a runaway slave and her two children were brought to the house on their way to freedom.

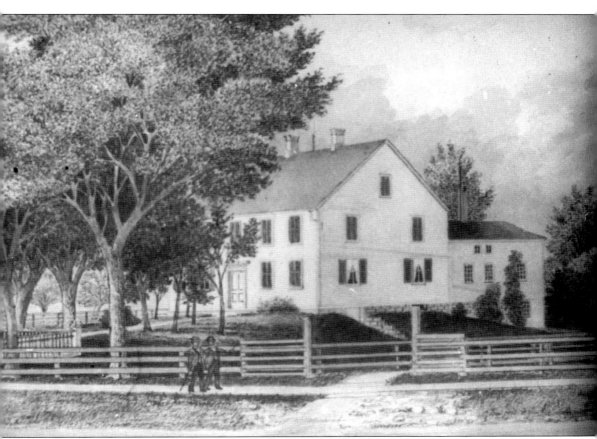

David Hudson was opposed to slavery. He believed in "colonizationism," a concept that supported freeing the slaves and sending them back to Africa to help set up a democratic government there. Regardless of abolitionism or colonizationism, his house in Hudson was a stop on the Underground Railroad.

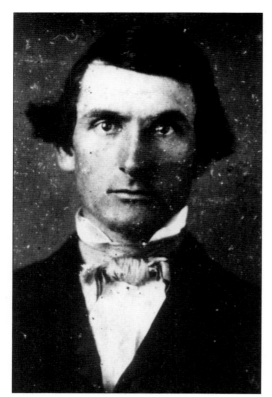

Named for his grandfather of Aurora, Ohio, Jeremiah Root Brown was born November 17, 1819. He was John's younger half-brother. His mother, Sally Root Brown, was Owen Brown's second wife. Upon Sally's death, Owen married Lucy Hindale. Jeremiah married Lucy's daughter Abi.

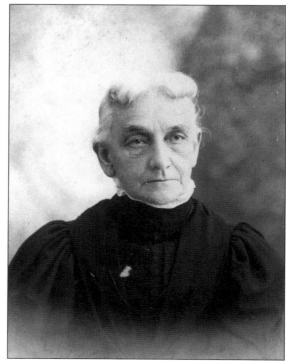

Martha Brown was John's half-sister and Owen's youngest daughter by Sally Root Brown. She married J.B. Davis and moved to St. John's, Michigan.

John Brown's half-sister Sally Marian was born in Hudson. She married Titus Hand, and they moved into a house on North Main Street built by Owen Brown in 1834. The house was probably a stop on the Underground Railroad.

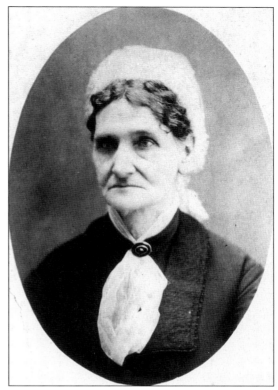

This house has the only 19th century gambrel roof in Hudson and possibly in the entire Western Reserve. Built in 1832 by Elizur Wright Jr., it was one of the stops on the Underground Railroad. Wright came to Ohio with his father from Connecticut. He taught mathematics at Western Reserve College from 1829 until 1833, when he resigned amidst the abolition/colonization wrangling. He became nationally known as an abolitionist. Wright is also known as the "father of American life insurance" for his work on actuary tables.

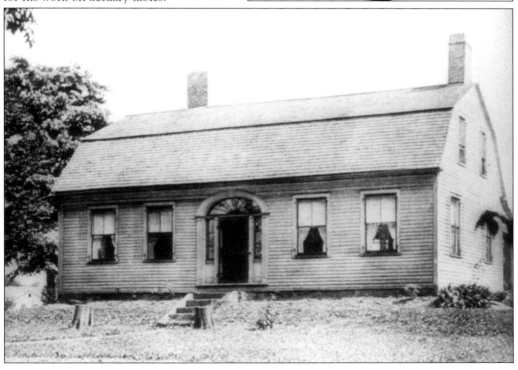

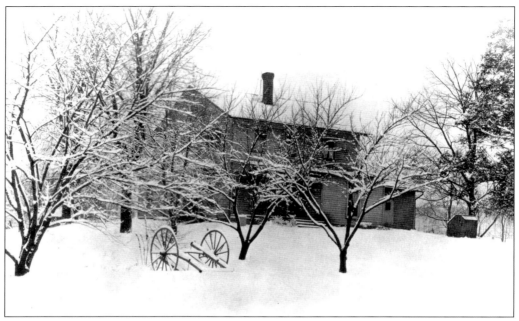

This is another view of the John Brown Tannery House. John Brown Jr. told of how slaves were hidden at the tannery. He said they were taken to a place "where the creek meets the marsh." There was an encampment for slaves at Darrow and Hines Hill Road.

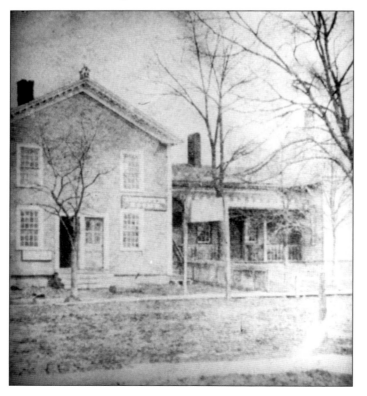

John Markillie's house in the 200 block of North Main Street is said to have been a stop on the Underground Railroad. Built in 1854, it stood next to a business building he co-owned with his stepson David Hurn. Markillie's photography shop was on the second floor of that business building. A covered stairway ran between it and his house. James Doncaster took over Markillie's livery barn behind the house. He was a wagon-maker and undertaker.

As the slavery issue quieted down on Western Reserve's campus, nearby Oberlin College acquired collegiate standing. The people of Hudson saw Oberlin as a rival. Oberlin also blatantly favored emancipation. Much to Hudson's dismay, Owen Brown, a financial supporter of Western Reserve, ruffled feathers by sending his daughter Florella (John's half-sister) to college at Oberlin.

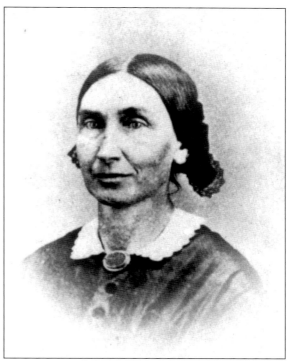

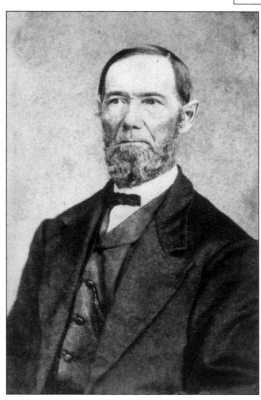

Samuel L. Adair was married to John Brown's half-sister Florella. Adair, a missionary, moved with his wife to Osawatomie, Kansas, to fight slavery.

Jeremiah Root Brown held the same abolitionist views as the rest of his family. He was married to Abi Hinsdale, and they allowed their house to be used in John Brown's schemes. Jeremiah died in Santa Barbara, California, on February 22, 1874.

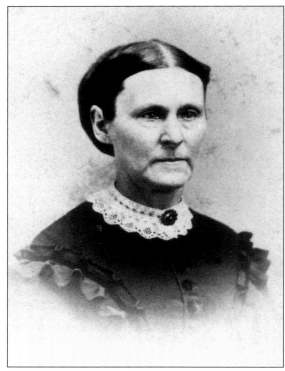

Abi C. Hindale Brown was married to Jeremiah Brown. Sometime after Jeremiah died, she built her own house down the street from where she had lived with her husband. Her mother, Lucy Hinsdale, was Owen Brown's third wife.

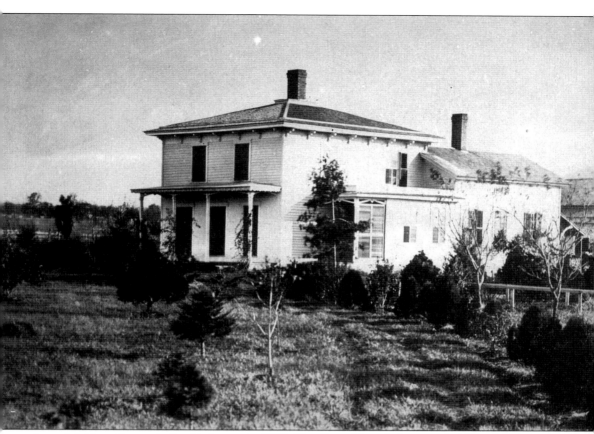

Jeremiah Root Brown built this house in 1853. He allowed his abolitionist half-brother, John Brown, to hide guns on his property for the Harpers Ferry raid. A dry cistern near the house may have hidden runaway slaves as a part of the Underground Railroad.

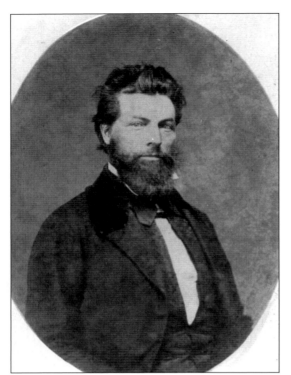

John Brown Jr. (1821–1895) was his famous father's first-born son by Dianthe Brown. At the age of four, he witnessed his father hiding fugitive slaves. When he was grown, he and his brothers moved to Kansas to work against slavery. John Sr. visited his sons, and in 1856, the Browns killed five pro-slavery settlers. John Jr. later suffered a mental breakdown.

Lucy Hinsdale was the widow of Harmon Hinsdale. She lived next door to Owen Brown and his second wife, Sally Root. After Sally's death, the 71-year-old Brown married Lucy and moved into her house.

When "western fever" hit, Salmon Brown, another of John's sons, went to Kansas with his brothers. Salmon was involved with the Pottawatomie Massacre, but did not participate in the Harpers Ferry Raid. He later moved to California and ended his own life in 1919.

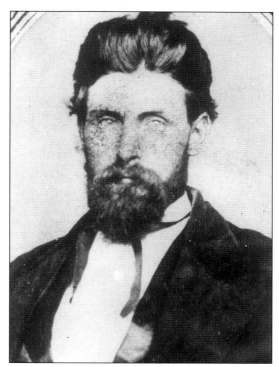

Lucy Brown Clark was the daughter of Jeremiah and Abi Brown. She moved to Kent, Ohio, where she lived for the rest of her life.

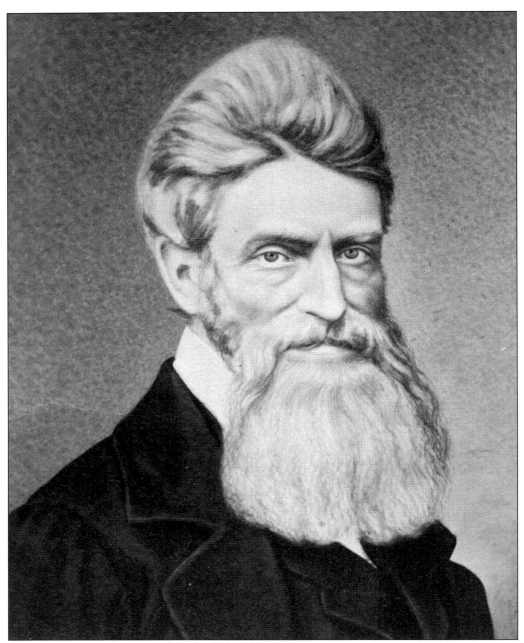

In 1856, John Brown and his sons staged the Pottawatomie Massacre in Kansas where five supposed slave owners were murdered. One of his sons, Frederick II, who had not taken part in the killing, was murdered in retaliation. In 1859, while attempting to provoke a slave rebellion, John Brown and 18 others raided the federal arsenal at Harpers Ferry. U.S. marines under Robert E. Lee's command killed or wounded 13 insurgents, including two of John's sons, Oliver and Watson Brown. A third son, Owen, made it to freedom. A wounded John Brown was captured. A Virginia court tried John for treason, insurrection, and murder, found him guilty, and hanged him on December 2, 1859.

Four
WESTERN RESERVE COLLEGE

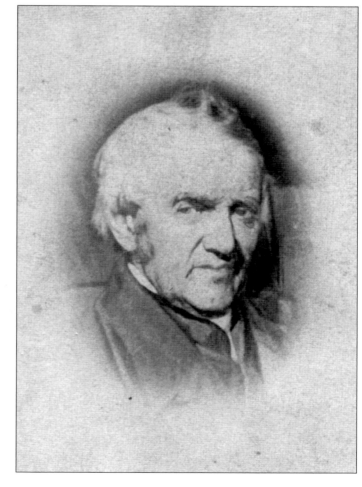

Connecticut-born Caleb Pitkin (1781–1864) was educated at Yale and ordained as a minister. He came to Charlestown, Ohio, as a missionary in 1816. He and David Hudson were instrumental in establishing the Western Reserve College. The charter was signed February 27, 1826, and Pitkin was named the first president of the board of trustees. The cornerstone for the school was laid on April 26, 1826, resulting in the building known as the Middle College. During the ceremony, Pitkin delivered his oration in Latin. He was married to Anna Henderson and had five children.

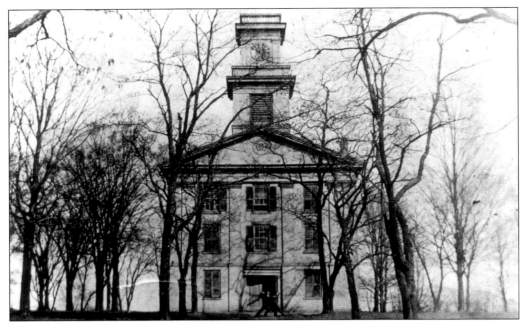

The dominant building on the Western Reserve campus is the Chapel. Built from a mail-order design in 1836, it has classrooms on the first floor. The chapel occupies the second and third floors. It is the only structure of its kind in northeast Ohio. It served as a meeting place for the first Episcopalians before their church was built. In 1925, it provided the quiet, simple setting for James W. Ellsworth's funeral. In 1940, a 22-foot section was added to it. It was renovated in 1964.

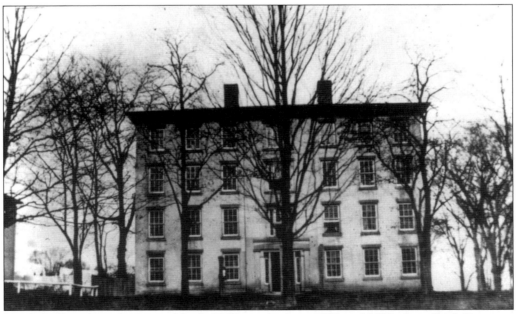

North College (now known as North Hall) was built in 1837 and 1838 along Brick Row as a dormitory for theology students. Construction costs for the 4-story building topped $8,000. It was restored in 1961.

Reverend George Edmond Pierce (1794–1871) succeeded Reverend Charles Backus Storrs as president of Western Reserve College in 1834 and served as the second president until 1855. Storrs died in September of 1833, but not before participating in controversies over slavery. Pierce, a Yale graduate, oversaw several improvements for the college: increasing enrollment, doubling the faculty, enhancing the science department, building the Chapel and observatory, fencing the grounds, and setting up a medical department in Cleveland. Eventually, the cost of these improvements exceeded the income of the college. At the age of 60, Pierce stepped down, leaving the college in debt.

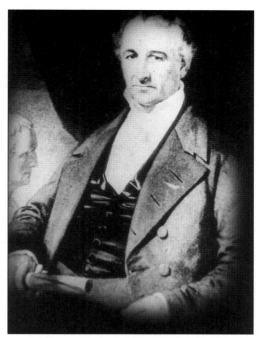

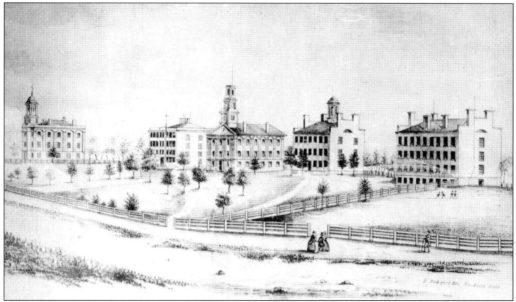

This drawing of Western Reserve College shows five of the original buildings on Brick Row. On the far left stands the Athenaeum; built in 1843 as a science building, it was the largest of the original structures. The first two stories consisted of classrooms and the third was a museum. The tower was removed in the 1860s and a fourth floor was added in 1917. The other buildings from left to right are North College (1837–1838), the Chapel (1836), Middle College (1826), and South College (1829). The Middle College was the first building on the campus, constructed for $5,500. For a 50-year period, the South College housed the Preparatory School. Both Middle and South College buildings are gone.

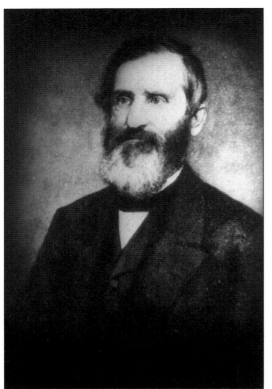

Henry Lawrence Hitchcock became the third president of Western Reserve College in 1855 and held that post until 1871. The native Ohioan managed to free the school from huge debt and increase enrollment. He appointed Edward W. Morley as a professor of chemistry. Morley was responsible for the first student hands-on laboratory west of the Alleghenies. It was during Hitchcock's presidency that the young James W. Ellsworth enrolled in the preparatory school. Hitchcock resigned for health reasons, but continued to manage the school's finances until he died in 1873. He left Western Reserve financially sound.

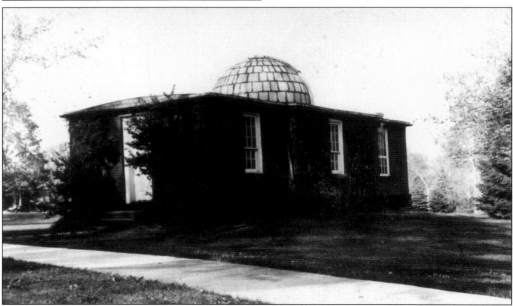

The Loomis Observatory is at the southern tip of Brick Row. Opened in September 1838, it housed state-of-the-art instruments and a telescope. It was one of the first observatories in the United States. It was there that Elias Loomis conducted studies in astronomy and meteorology that brought the school national recognition. The photograph was taken by Richard Smith of Hudson.

Elias Loomis (1811–1889) came from Yale to Western Reserve College in 1837 as a professor of math and natural philosophy. President Pierce soon sent him to Europe to study astronomy and purchase equipment, including a telescope, for an observatory. Loomis helped design the observatory and oversaw its construction. He taught at the school until 1844.

Nathan Perkins Seymour was a professor of Greek and Latin at the college from 1840 to 1870. Seymour bought a lot on Prospect Street, facing College Park, and built his house. The land had been previously donated to the college by the Harvey Baldwins. Other professors also bought lots on the land, but didn't build.

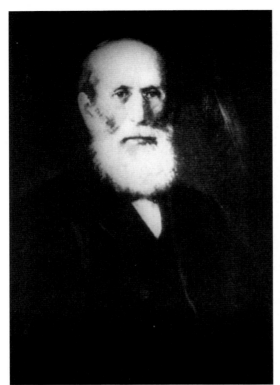

After Hitchcock resigned in 1871, Carroll Cutler was promoted to president. With Hitchcock overseeing the finances and Cutler as president and professor, the college ran smoothly. When Hitchcock died, Cutler was unable to keep up with the demands of increasing expenses. Finally, wealthy Clevelander Amasa Stone offered the college $500,000 if it would move to Cleveland. The board accepted the offer, and in 1882 the college moved, leaving the Western Reserve (preparatory) Academy behind. Today, the college is known as Case Western Reserve University. The preparatory school closed in 1903, but reopened in 1916 with the help of James W. Ellsworth.

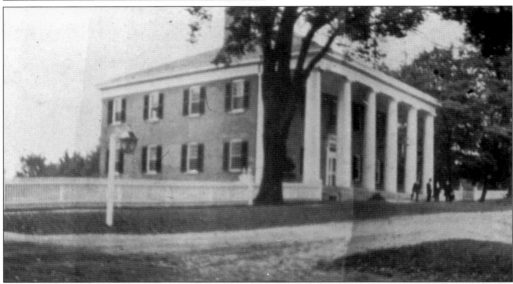

This structure was originally a cheese warehouse and factory built by Seymour Straight in 1878. It was next used as a mill. In 1907, James W. Ellsworth had it renovated to be used as a clubhouse for Hudson. It was bequeathed to the Academy, and through the years used as a primary school, a restaurant, and the Hudson Country Day School. Finally, in 1932, the Academy moved the music department into it, and it was renamed Hayden Hall for Headmaster Doctor Joel Hayden.

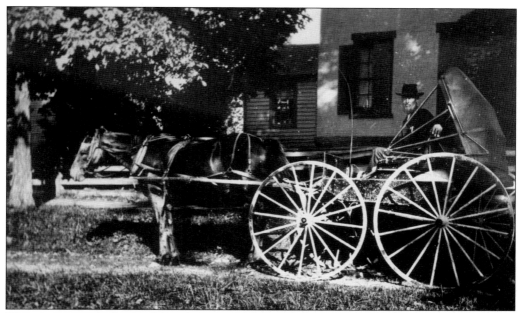

The caption on the back of this photograph identifies the man as Carroll Cutler in front of his house at 169 College Street. Cutler was a philosophy professor at Western Reserve College and was president of the college from 1871 to 1886. The house was built in 1839. Cutler lived there until 1882 when the college moved to Cleveland.

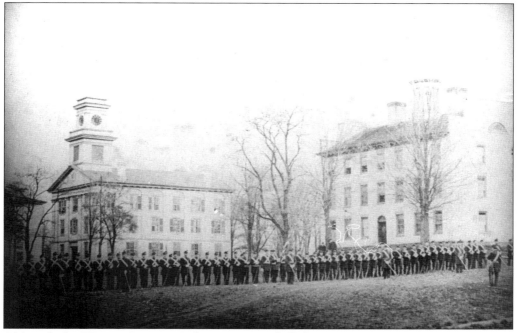

Although the Western Reserve College regiment drilled on campus during the Civil War, this photograph was probably taken in 1879. Here the military unit has formed a line in front of the Chapel (left) and the Middle College.

Born a slave in Virginia and liberated by General Joseph Hooker, William Branch came to Hudson. He worked at Western Reserve College as a drayman and assistant.

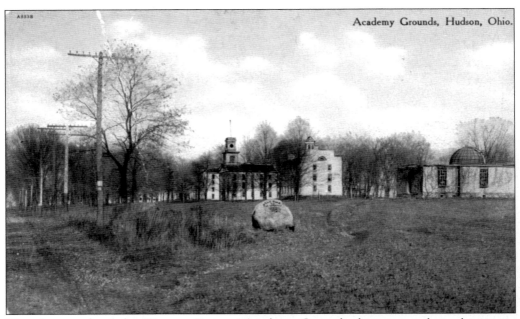

The photograph of the Western Reserve Academy Grounds that appeared on this penny postcard was taken sometime after 1884 when South College was torn down. The buildings, from left to right, are the Chapel, the Middle College (torn down 1912–1913 to make room for Seymour Hall), and the Observatory. The rock in front bids "Welcome."

James W. Ellsworth gained title to the Academy campus in 1912. He failed to bring a college back to Hudson, so he concentrated on the Academy. South and Middle Colleges were torn down, Seymour Hall was built, and other renovations took place. Finally, in 1916, Western Reserve Academy was reopened. It was co-educational at first, but in 1925, it became an all-boys preparatory school per the James W. Ellsworth Foundation. Ellsworth is pictured here in July of 1920 at his castle in Switzerland, known as the Schloss Lenzburg. He died in June of 1925.

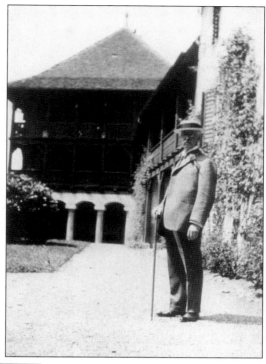

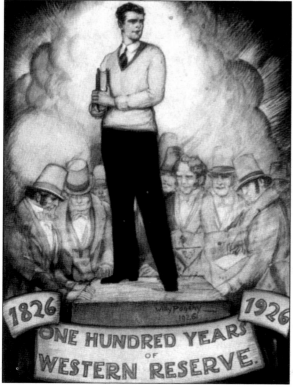

This cover was designed in 1926 for the Western Reserve Academy's centennial booklet. It is signed by Willy Pagony.

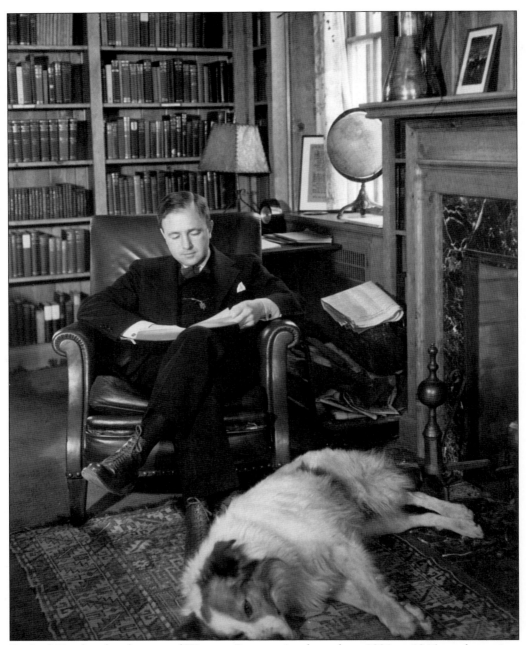

Dr. Joel Hayden, headmaster of Western Reserve Academy from 1931 to 1946, made music a significant part of the curriculum. Hayden Hall at 88 College Street is named in his honor and housed the music department. Henry M. Mayer of Cleveland took this photograph of Dr. Hayden in 1926.

Five
MAIN STREET

James Markillie came to Hudson from England with his mother. He was a photographer and enjoyed oil painting as well. His photography shop was in the 200 block of North Main Street. Today, his photographs give historians an accurate view of 19th century Hudson. At least one of his paintings is preserved at the Hudson Library and Historical Society. When his mother died, he donated two acres from his horse pasture to the village for a cemetery so that she could be buried under her favorite elm tree.

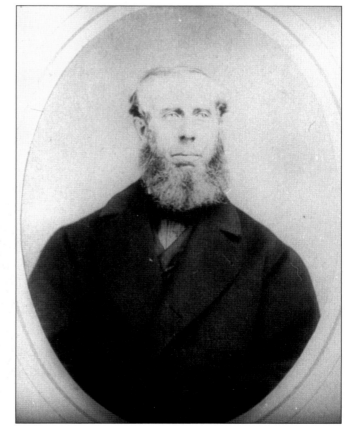

Lucy Hurn Markillie came to Hudson from England in 1833 with her son David Hurn, daughter Hannah, son-in-law William Doncaster, and James Doncaster. They sailed aboard the *Westmoreland*. John Markillie was her second husband.

The buildings in this early photograph are labeled Dr. Roger's house (right), Josiah Strong's house (middle), and David Hudson's barn at far right. Rogers was a dentist. His house, called Wayside, was built by John B. Whedon in either 1828 or 1833. Whedon's daughter Mrs. E.E. Rogers lived there for the remainder of her years. Owen Brown built the Strong house in 1834. Brown's son Oliver sold it to fellow abolitionist Ephraim Strong.

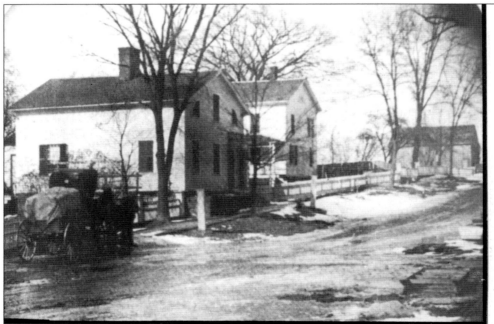

Dr. Roger's House - Josiah Strong's House - David Hudson's Barn

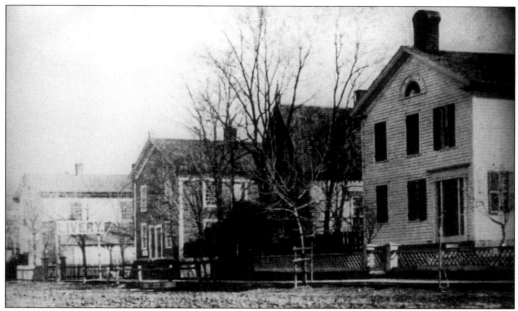

The house in the foreground is known as the Wooden-Farrar house, built by bootmaker Elixius S. Wooden in 1832. John Markillie's house, livery, and the Hurn-Markillie business buildings are in the center. Markillie took this photograph in about 1860.

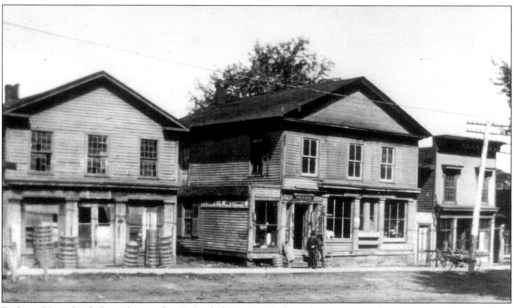

Robert Hine built his "frame shop" (at left) in 1842, but there is no definitive record as to what business actually took place there. It is known that he sold it to George Veader in 1844. After Veader's tragic death, his widow sold it to John Nutting Farrar, who operated his tin shop there for many years. Next door is the structure built by Owen Brown in 1834 for J.B. Whedon's dry goods store. It later became C.A. Campbell's harness shop. S.E. Rideout, who owned it at the turn of the century, took this photo in about 1905.

John Hine built this house on North Main Street in 1840. Chauncey Fowler, a harness maker, and his descendants also owned it. The women in the photograph are identified as Mrs. Crawford, mother of Luella C. Dodds (seated), and Mrs. Fowler, grandmother of Elvira Post (standing).

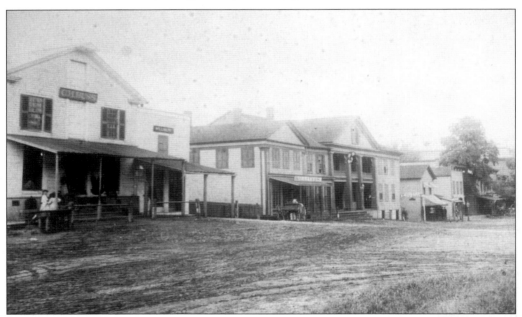

This photo of the west side of Main Street was taken sometime between 1842 and the Fire of April 28, 1892. The Buss Store is on the left. Lockhart's Saloon and the Mansion House were in the middle. A sign directing customers to Laudenslager's livery, in the rear of the buildings, can be seen to the right of the Mansion House. Wehner's Dry Goods and the Miller building is at far right. The livery was far enough away from the row of stores that it did not burn. After the fire, village officials passed an ordinance permitting only stone, metal, or brick construction.

At left is one of the oldest commercial buildings in Hudson. Edgar Birge Ellsworth built it as a general store in 1841. Throughout its history, it housed a bake shop, a meat market, a plumbing contractor's office, an antique shop, and a dentist's office. Next door is A.W. Lockhart's house built in 1889 and 1890. Lockhart operated a bakery in Ellsworth's store for a time, and he was the owner of Lockhart's saloon where the Fire of 1892 started.

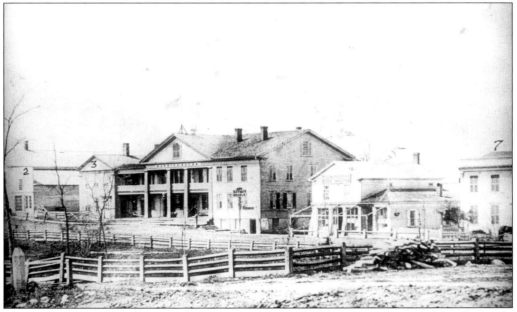

The Green, or Park, was fenced at one time. The buildings are numbered in this early photograph and identified from left to right as the Baldwin-Buss Store with Justice of the Peace Office, Lockhart's Saloon, the Mansion House, the Veader-Holmes-Wehner Store, Seymour's Shoe Shop, and John Hanford's Townhouse.

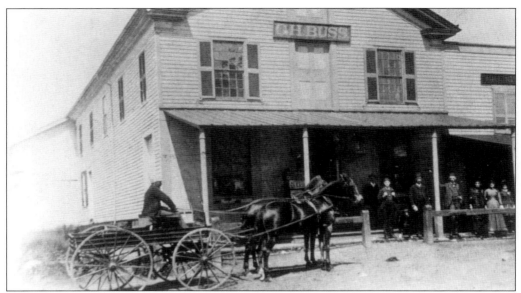

C.H. Buss's store on North Main Street was originally Baldwin Dry Goods, built by Augustus, Frederick, and Norman Baldwin in 1815. The building was replaced in 1829. That structure was condemned by the state fire authority in 1842 and replaced by the building pictured above. A former Western Reserve student, John Buss, became the next owner. The annex (to the right) was added in about 1844. At one time, it was an office for the Justice of the Peace. John's son, Charles Buss, owned the store when it was destroyed during the Fire of 1892. The annex, also leveled by flames, held Miss Belle Mills's millinery shop.

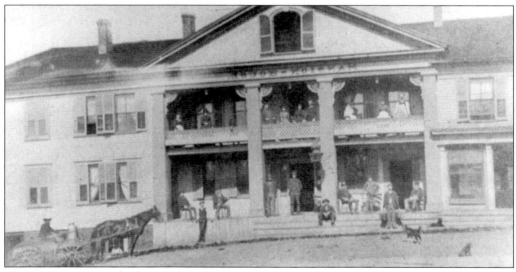

The Mansion House, built by Judge Van Rensselaer Humphrey in 1835, was a popular hotel and stagecoach stop on North Main Street. It was the first 3-story building in the Western Reserve. It burned down during the Fire of 1892. There were no reported casualties in the hotel, probably because a porter named Albert Hottinger rang a bell to awaken the guests. Business declined after the college left Hudson, and the Mansion House had six other owners until it burned in the Fire of 1892.

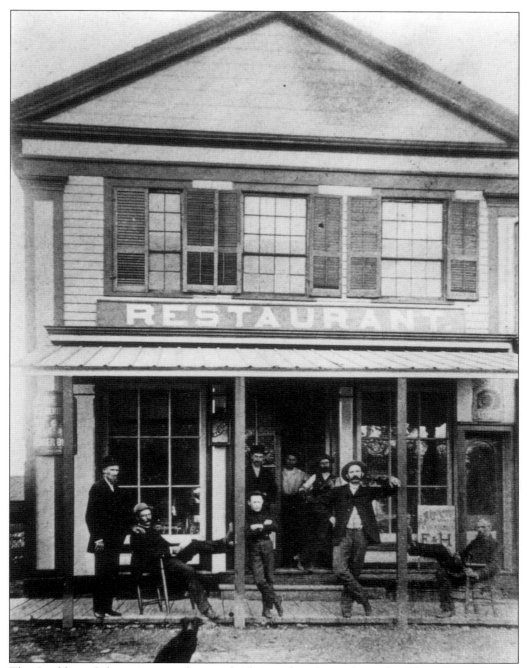

The Lockhart Saloon is most famous for being the place where the Main Street Fire of Thursday, April 28, 1892 started at 3:30 a.m. Built in 1846, it was a restaurant owned by W.L. Garnes, before A.W. Lockhart took over and made it a saloon featuring billiard tables. The cause of the fire was never discovered. Although the village council offered a $200 reward for information, no one ever stepped forward. It was always believed the fire occurred in connection with closing down the drinking establishments.

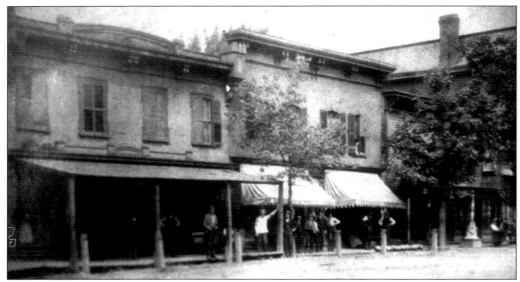

This is a photograph taken of Main Street in the 1870s. It shows the Campbell and Miller blocks, and the Farrar block is on the far right.

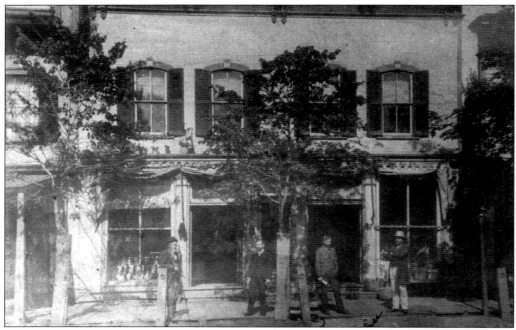

This 1885 photograph shows the Miller block before the Fire of 1892 destroyed it. George V. Miller sold meats, groceries, and tobacco from this building. He shared it with his brother Ralph, who was a baker. Another brother, Sebastian, was a shoe merchant with a shop a few doors away. The structure was built in 1861 and was much smaller. George Miller enlarged the building in 1881. After the fire, George rebuilt his store. The new building was brick with a pressed metal false front. The men in the photograph are, from left to right, Henry Holmes, Sebastian Miller, George Miller, and Chauncey Case.

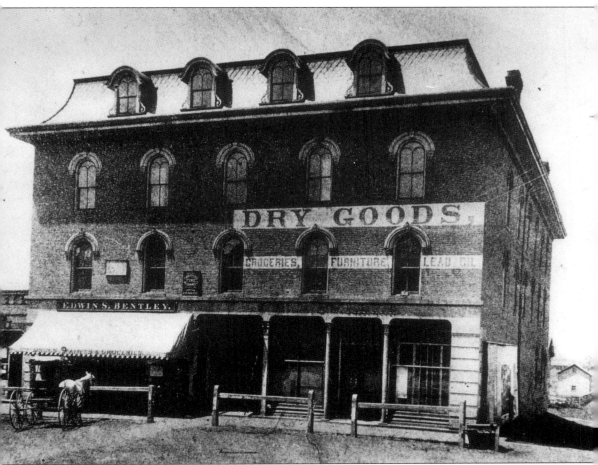

The original building at the corner of North Main and Clinton Streets was a brick hotel, the American House, built in 1831 by Julian Lusk. In 1866, Charles Farrar expanded and remodeled it, adding the 620-seat Adelphian Hall. The hall was host to performers, lecturers, and Anner Maria Hudson Baldwin's 90th birthday dinner. A dry goods store, drugstore, and offices were downstairs. Although the Fire of 1892 destroyed the Farrar Building, its brick construction slowed the fire until the rain could drown the flames.

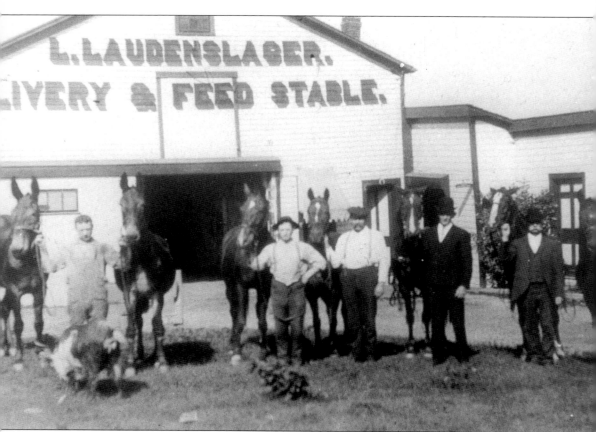

A sign pointing down an alleyway close to the Mansion House Hotel directed customers to Lyman Laudenslager's Livery and Stable. Located west of the Main Street buildings, it survived the Fire of 1892. Laudenslager stayed in business into the 20th century. By 1910, he realized the livery business would give way to automobiles. He was the first car dealer and ordered ten Model Ts for Hudson residents.

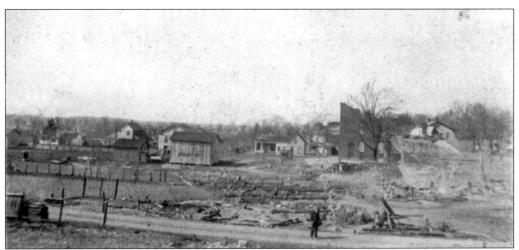

The early morning fire of April 28, 1892 devastated village businesses. Buildings lost in the fire were the Buss Store, the Mansion House, Lockhart's Saloon, the D.J. Joyce Grocery, the Miller store, Wehner's Dry Goods, the post office, a pharmacy, two doctors' offices, the Adelphian Hall, and many others. The township records were destroyed, as was Mayor Matthew C. Read's library. Damages were in excess of $130,000. Most of the proprietors were uninsured. The determined businessmen rescued what they could and set up shop in hastily-built sheds on the Green or anywhere there was space. Ralph Miller set up his bakery in the Methodist Church, while his brother, George, moved his butcher shop into the business space of James Doncaster, the carriage maker and undertaker.

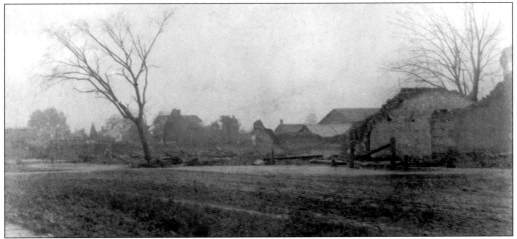

The Fire of 1892 leveled North Main Street from Buss's Store to the Farrar Building at Clinton Street. It began in the back of Lockhart Saloon and immediately spread to the Mansion House. The porter there, Albert Hottinger, rang a bell to awaken guests. Miss Nellie Beebe tolled the bell of the Episcopal Church. A wind kicked up and the flames began to eat everything in their path. The water supply, held in large cisterns, and manpower were inadequate. As the flames danced on rooftops, the call for help went out to Ravenna, Newburg, and Akron. Only Akron responded. They loaded their engine and horses on a special train, but by the time they arrived, the whole block was gone. A combination of the crumbled brick walls of the Adelphian Hall and rain finally put a stop to the destruction.

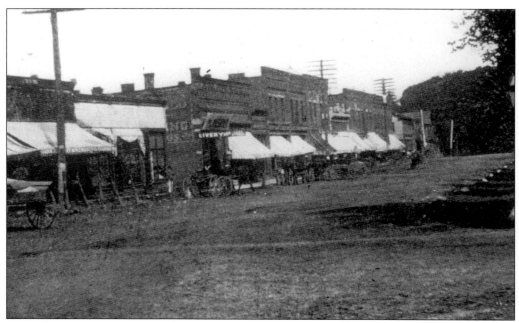

This was Main Street looking north from Church Street after the Fire of 1892.

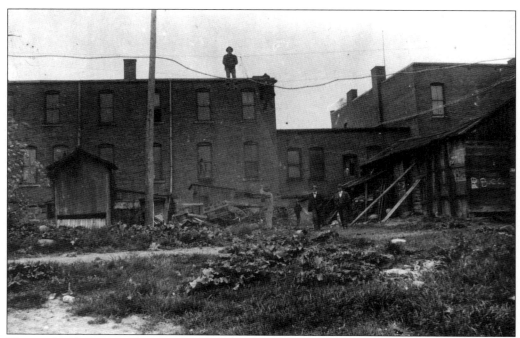

This undated photograph was taken behind the Main Street stores.

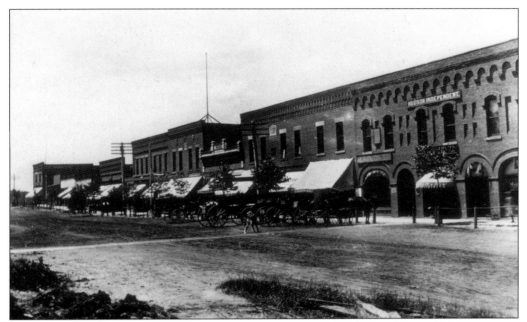

After the fire destroyed the wooden buildings on the west side of Main Street, the store owners rebuilt using brick, stone, and metal. This is a view of the new buildings looking south from Clinton. It was taken about 1909. The building at left burned in 1911.

Thirteen coal oil street lamps were installed downtown in 1878. They were encased in glass and sat on high poles. Each one was tended by whomever lived the closest. A lamplighter was hired the next year. He was paid 1 cent per light each night and was given a raincoat and boots. After a few years, more lights were installed and gasoline was substituted for oil. One of the lamplighters was George Gannon, pictured above.

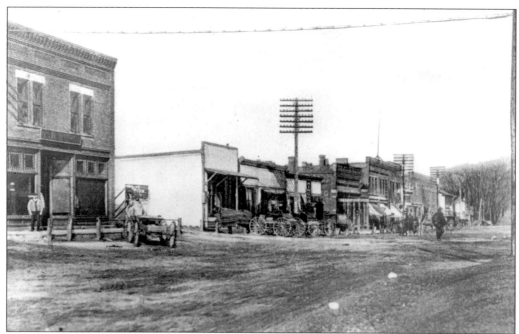

This photograph of Main Street looking north is not dated, but it was taken before James W. Ellsworth's improvements.

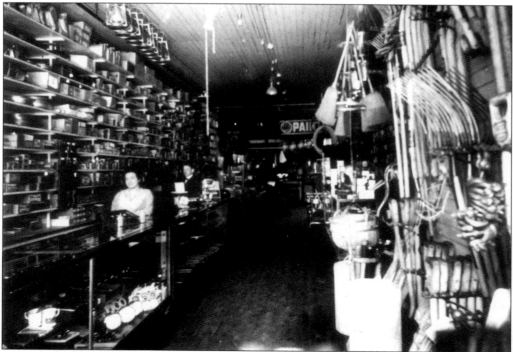

Until 1900, when the Produce Exchange Bank came to Hudson, C.H. Buss's store cashed checks. This is an interior view of the store c. 1900.

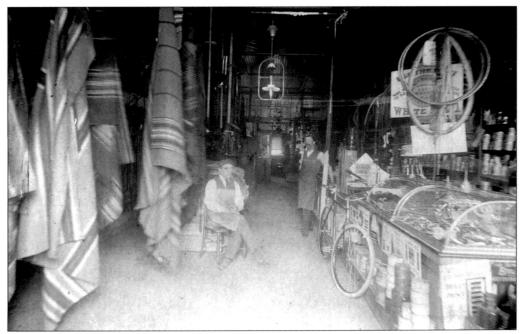

Cornelius A. Campbell's Harness and Hardware Store was one of the businesses that was immediately rebuilt after the Fire of 1892. This photograph of the interior of the store was taken in the 1890s. Campbell lived in a house on North Main Street and was one of the first residents to have a telephone and refrigerator.

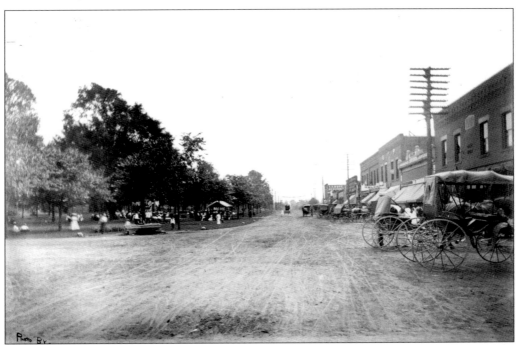

The camera looks south on Main Street during Home Days of 1907. The Green is on the left.

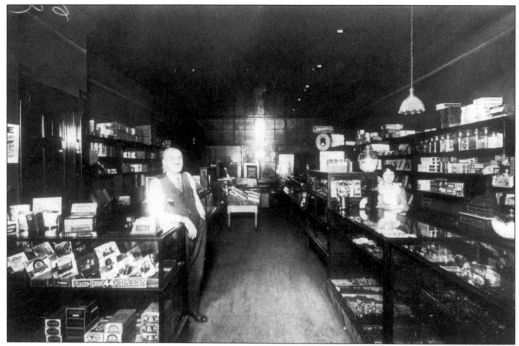

In 1899, Henry M. Darling opened the H.M. Darling & Son News Depot in the Campbell block. This photograph of the interior of the store was taken in about 1911. The man is not identified, but the young girl is Verda Jacobs Winfield, who went to work at the newsstand when she was 16. Born in 1895, she called Henry Darling "Daddy." She remembered that the store sold candy and tobacco. Darling was a Justice of the Peace and Notary.

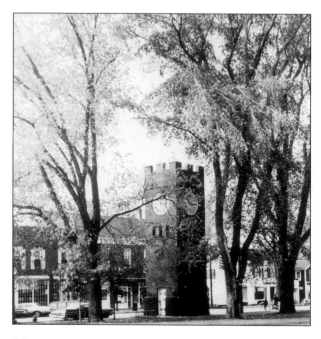

This photograph shows Hudson's signature clock tower and Main Street through the trees of the Green. It was probably taken during the early 1950s.

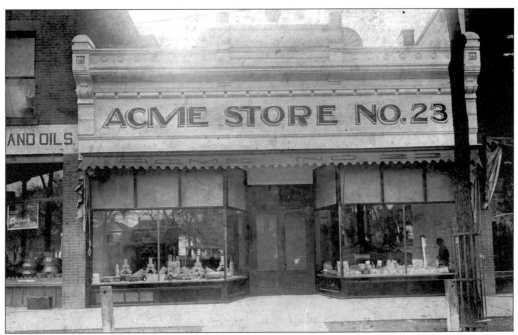

The F.W. Albrecht Grocery Company opened Acme Store No. 23 at 140 North Main Street in 1913. Fred Pockrant was the district manager and Rudy Ryan was the new Hudson's store manager.

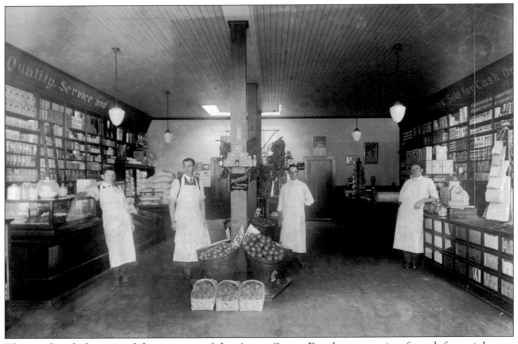

This undated photo is of the interior of the Acme Store. Employees posing from left to right are John Kohl, Harry Pettingell, Alvin Wenger, and Emmitt Rushton. Pennrod Motor Oil sold for $1.18 for two gallons and Wisconsin Brick cheese sold for 15 cents a pound at the time.

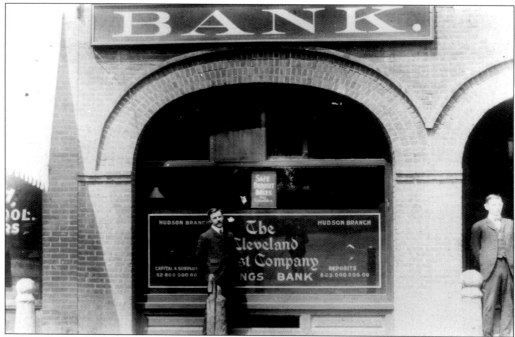

The Cleveland Trust Company, shown in this undated photograph, was not the first bank in Hudson. Previously, the Produce Exchange Bank of Cleveland, which opened in the same building as Saywell's Drugstore, served the community. The bank prospered for a few years, but was forced to close its doors when one of the officers embezzled between $150,000 and $200,000. What was left of the assets was assigned to The Cleveland Trust Company.

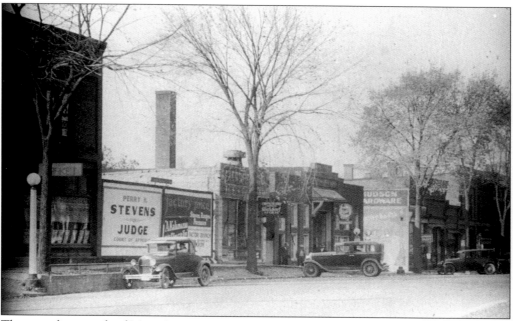

This is a photograph of Main Street taken in the 1920s.

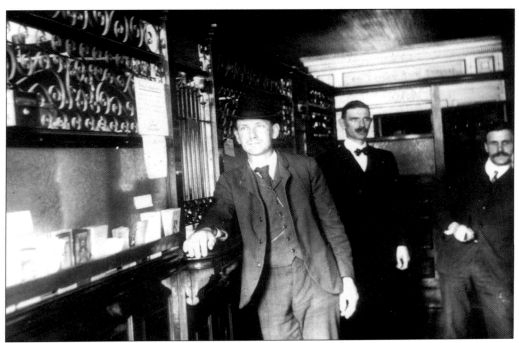

This photograph is labeled "Boys at the Bank." The image has no date and the bank is not identified. No names were given for the men in the photo.

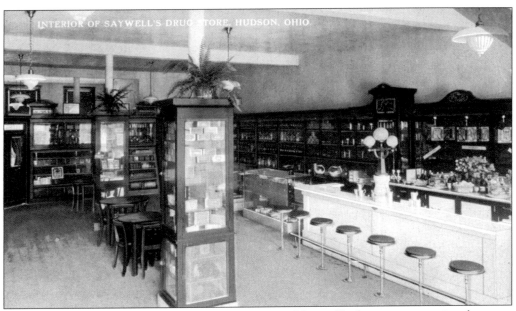

This photo is a penny postcard view of the interior of Saywell's drug store sometime between 1912 and the 1930s. In 1933, when liquor became legal again after Prohibition, the druggist acquired a liquor license. Today, Saywell's at 1600 North Main Street has not changed.

Mr. and Mrs. Sanchee owned the Hudson Inn on North Main Street for a short period of time. This photograph is dated 1923.

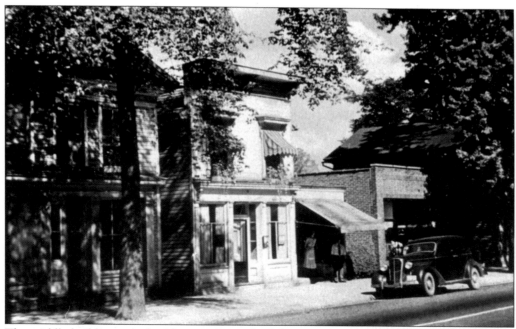

The middle buildings are the Noonan Shops, built by carpenter William Noonan, who did the fine carpentry work at Old St. Mary's Catholic Church. He built the two shops in February and November of 1867. His brother, John, was a bootmaker who engaged in his trade in the smaller, adjacent shop on the north side.

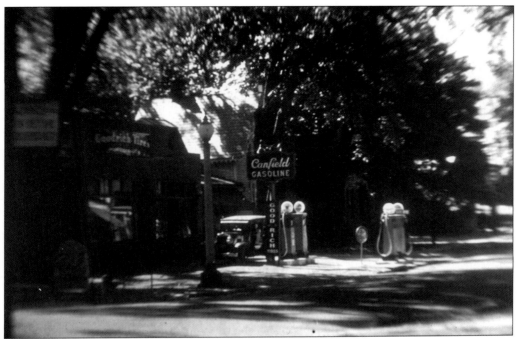

Dated 1923, this photograph shows the service station on the east side of North Main Street (looking south). It sold Goodrich tires and pumped Canfield gas from gravity flow glass tanks.

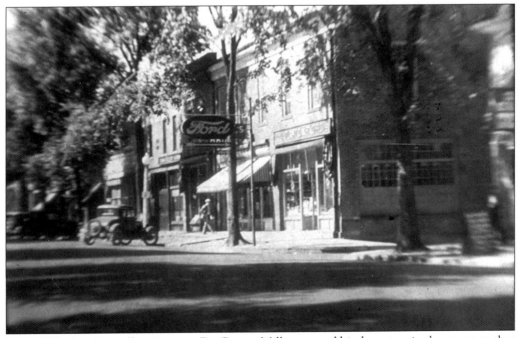

In 1909, Fred A. Saywell, assistant to Dr. George Miller, opened his drug store in the structure that had replaced the Farrar Building. In 1910 or 1911 a fire forced him to move a few doors south, but in 1912 the store was refurbished and reopened. This is a photograph taken of the building in 1920.

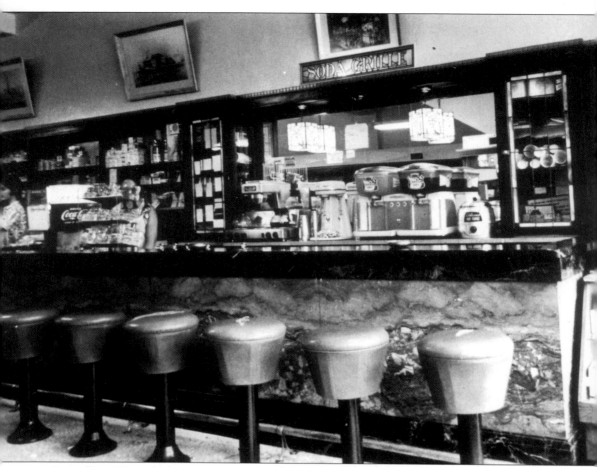

Saywell's 1930s soda fountain was, and still is, a popular gathering place.

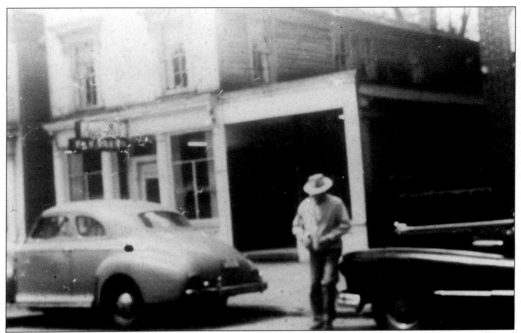

William Noonan built this shop and its annex in 1867. He sold the building to Cornelius Campbell in 1870. His brother, John, stayed in his little shop making boots and shoes for 17 years. Today, the Learned Owl occupies the entire building.

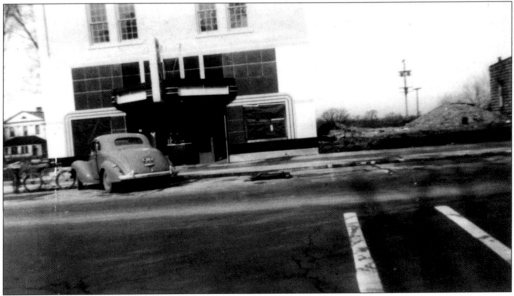

In 1940, the Hudson Theatre was opened on the original site of Buss's General Store. The structure was built down to street level and remodeled to include a slanted floor inside. Gerald Huff began managing the movie theater in 1943, and went on to purchase it in 1952. Business began to wane around 1959 when the schools discouraged children from going to the movies on weekdays. He closed the theater in 1962. It was then torn down.

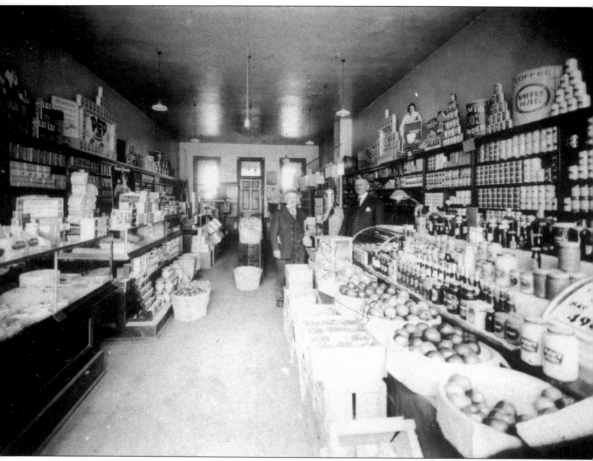

This 1930 photograph shows the interior of Dennis J. Joyce's Grocery Store at 116 North Main Street. Joyce was burned out in the Fire of 1892, but was back to selling groceries within 24 hours. He rebuilt his store within a short period of time. He was born and lived his entire life in Hudson. It is said that Joyce would give his customers the cold shoulder if he found out they patronized another grocery.

Six

EVERYDAY

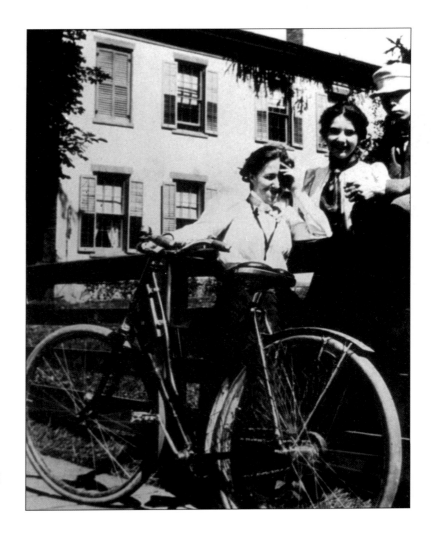

This photograph, taken in about 1910, shows two young women and a boy with their bicycle.

$50 REWARD!

WILLIAM R. WARNER hired a Horse and Buggy of me, to go to Twinsburgh, [...] 18th inst., and forgot to return. The Horse is dark bay, nine years old, black ma[...] [...]d tail, and black legs, and about 15 hands high, a small sore or two on his back, cau[...] [...] the saddle, and slightly calked on both hind feet.

The Buggy is a good top buggy, recently painted black; oil leather top, with side lig[...] [...]th silver plated frames; wood axletree; trimmed with drab sattinet on the seat, a[...] [...]ab broadcloth head lining. One of the bows has been mended with an iron on [...] [...]side, and is mostly concealed by the festoons. The buggy is very heavy for [...] [...]rse. [...] thills have been recently put in new, and are painted a dark lead co[...]

The thief is about 25 years of age, about 5 feet 9 or 10 inches high, had o[...] [...]raw hat, thin black coat, dark striped pantaloons, and had a gun in a green bag [...]se, formerly resided in Twinsburgh, Summit County, Ohio, but for a number [...]ars has lived in Finlay, Hancock County, Ohio, and registered his name at [...]vern as of Sauk, Sauk County, Wisconsin.

I will pay the above reward for the recovery of the horse and buggy and app[...] [...]ion of the thief, or $30 for the horse and buggy, and $20 for the thief.

JOHN MARKILLIE.

[...]dson, Summit Co., Ohio, July 20, 1854.

John Markillie offered a reward for the apprehension of William Warner, who rented a horse and buggy from Markillie's livery and failed to bring them back.

90

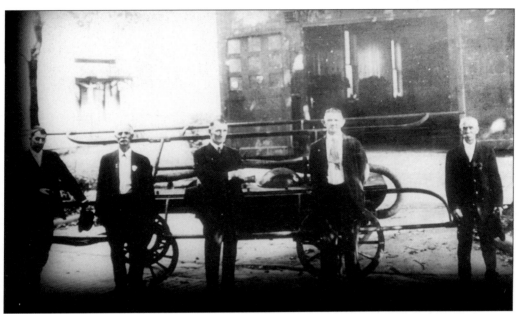

The Hook & Ladder of Hudson started in 1849. This is the fire department's 1858 Button & Blake hand pump. It took 16 men to operate and cost $621.17. It was retired in 1911.

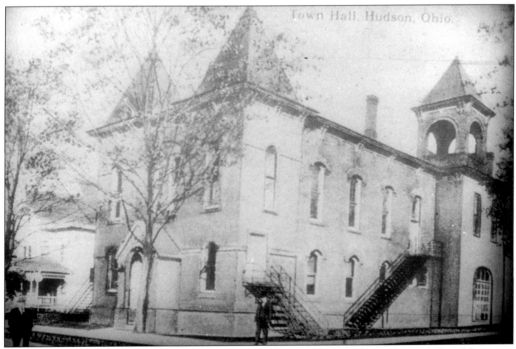

Town Hall. Hudson. Ohio.

The town hall was built in 1879 where the Congregational Church once stood. In addition to the public hall, which was on the second floor, it had a lock-up on the first floor. The Hudson Little Theatre also called this building home in 1940. In addition, it housed the draft board, ration board, and fire and police departments.

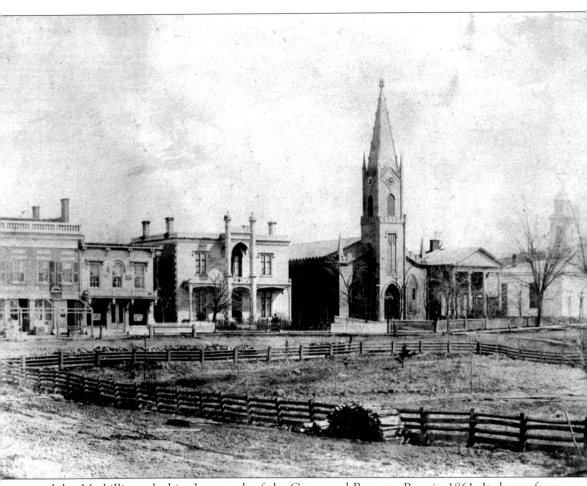

John Markillie took this photograph of the Green and Brewster Row in 1861. It shows, from left to right, the Brewster Store (1839), the Brewster Store annex, Brewster Mansion (1853), the Christ Church Episcopal (1846, replaced 1930), Isham-Beebe House (1834), and the Methodist Church (which was razed).

This carriage scene looks up Aurora Street at the Beebe House and Christ Church.

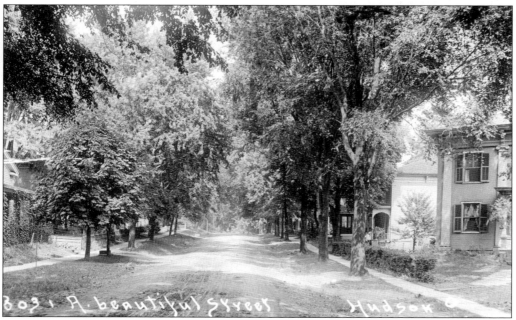

This "beautiful street" is Aurora looking east sometime during the late 1800s. At right is the Whedon-Farwell House which was built in 1826. The Henry Holmes House, built in 1876, is visible next door.

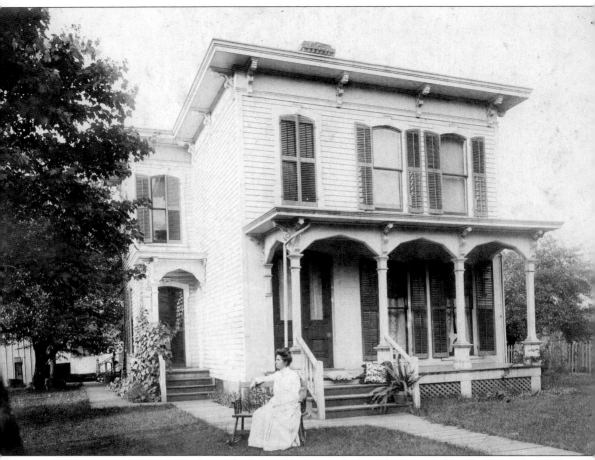

The George V. Miller House was built in 1878. Miller owned a grocery on Main Street that was destroyed in the Fire of 1892.

The description on the back of this carriage scene photograph reads: "North Main Street, east side." Buildings are thought to be additions to the Brewster building, torn down long ago.

This house was built some time in the 1890s and was owned by Luman Oviatt. The photograph was taken in about 1907.

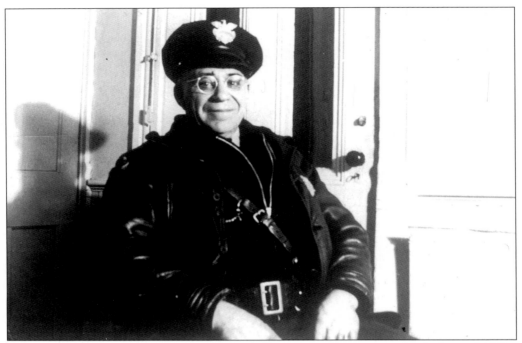

Percy L. Dresser was the Town Marshall of Hudson Village from 1930 through the mid-1940s. He also served as Constable of the Township, and at one time or another, held the titles of Street Commissioner, Marshall, Night Watchman, and Custodian of the Clock.

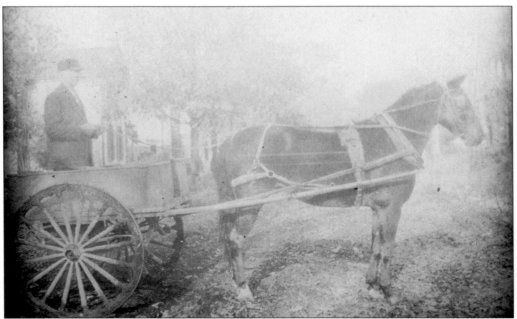

It was George Gannon's job to light the coal-oil streetlamps in Hudson until James W. Ellsworth had electric ones installed. Gannon drove from lamppost to lamppost in this two-wheeled cart. He kept the sidewalks free of snow in the winter, and also served as the village policeman.

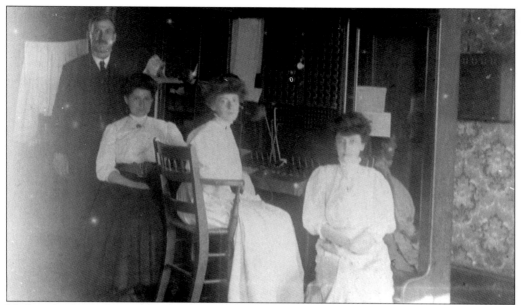

Hudson had telephone service very early. This 1907 photograph shows four of the Hudson Telephone Exchange employees. They are, from left to right, H.M. Darling, manager, Rose Luenenberger, Lily Melching, and Maud Melching. In 1910, James W. Ellsworth, a philanthropic Hudson resident, wanted to "get those abominable telephone wires out of the air." Weldon Wood, a Cleveland telegraph operator, knew how to put the wires underground. In 1910, he and Ellsworth formed the Hudson Underground Telephone Company.

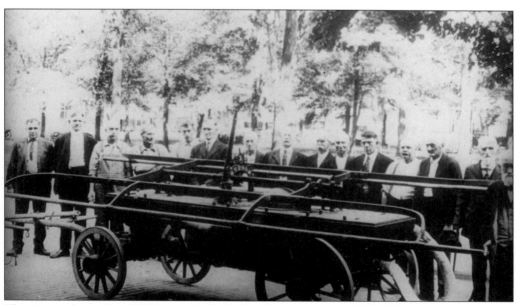

This image shows the 1858 Button & Blake hand pump surrounded by Hudson's fire company. The company consisted of Red Bishop, Walter Carey, Percy Dresser, Duff Billiter, Fred Greist, Frank Corbus Sr., Harry Pettengell, Lime Laudenslager, George Moore, Bert Lewis, Ed Saywell, Frank Bailey, Ray Pettengell, High Fox, William Arnold, William Bell, and Lew Holcomb.

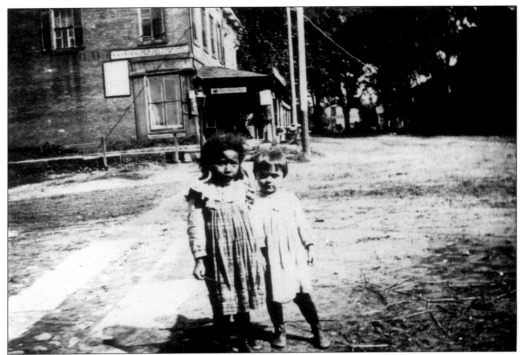

These two children are standing at the corner of Aurora and Main Streets. The building in the background was built by Anson Brewster in 1839 and was originally a dry goods store. At the time of this photograph, Giemmis Hardware occupied the downstairs front. In the back was a tin shop. Dr. Hodge, Lawyer Foster, and S.E. Judd (real estate agent and notary public) were upstairs occupants.

A group of circus performers pose for their photograph at the train station. No date was given.

Alfred Pettingell was an artist and naturalist from Hudson. He was noted for his paintings of butterflies. His brother William served as Treasurer of the Western Reserve College, and became Mayor of Hudson in 1862. His nephew built houses in Hudson.

This image is of Brewster Row looking east on Aurora Street. Writing on the back of the photo identifies the buildings in the background as the bank and the Episcopal Church. The Elm trees were planted at the behest of James W. Ellsworth. The names Robert Thompson, Gus "Grim", and Charley Corbus are listed on the back, but it is unknown which name corresponds with which person. Thompson was a prominent farmer. Gustave Grimm, founder of G.H. Grimm Manufacturing Company, has been credited with installing the first gasoline streetlight in Hudson at the pictured corner.

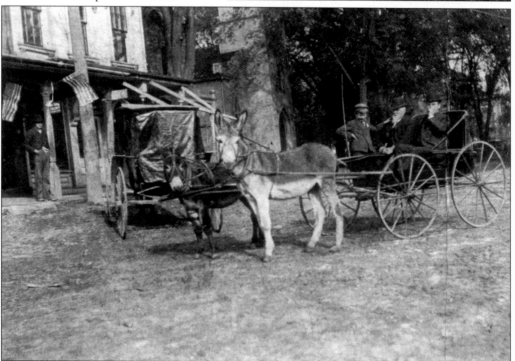

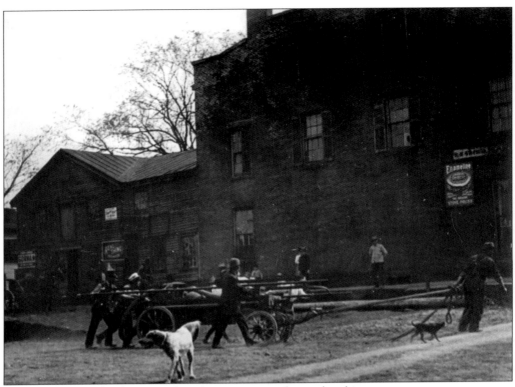

The fire department appears to be taking action in this undated image.

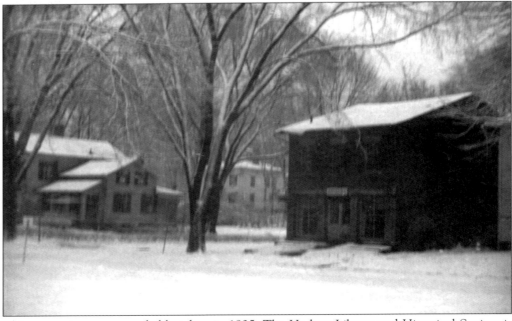

This snowy image was probably taken in 1935. The Hudson Library and Historical Society is on the left. The Ellsworth Store is on the right. Division Street runs between the two.

Members of the Grange at Darrowville posed outside the Grange Hall. Writing on the back of the image indicates it was taken before 1941, and Jeanette and Jay Dickey Coller are identified as being on the right side of the right window. They were the step-grandmother and grandfather of Henry Nebe.

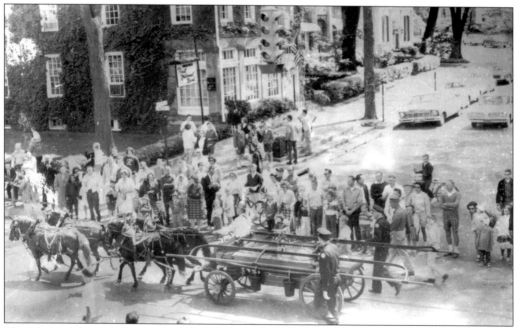

The Hudson Fire Department's old horse-drawn hand pump is brought out for a parade on Main Street.

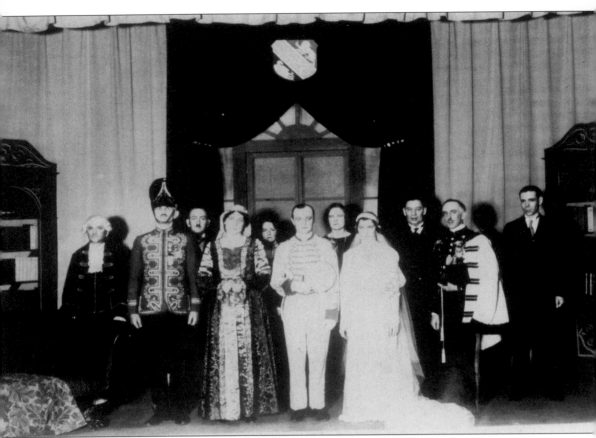

The play *The Importance of Being Earnest* was performed in 1932 in the Western Reserve
Academy Chapel for the benefit of the Hudson Primary School. Rowena Simon directed it.
The cast included, from left to right: (front row) Fred Ray, Russell H. Cleminshaw, Mrs. Robert
J. Izant (Grace), Edouard Exline, Mrs. Albert Neneman (Nan), Leon Baxter, and Albert
Neneman; (back row) Spencer Corlett, unidentified, unidentified, and Harold Bell.

Seven
ELLSWORTH

James William Ellsworth was born in Hudson on October 13, 1849, as the second son of Edgar Birge and Mary Dawes Ellsworth. At age 15, James enrolled in the Preparatory Department of Western Reserve College. The suggestion that he might go into the ministry horrified James. He much preferred the business world to his academic studies, and began to work in his father's store. At the age of 20, he set off for Chicago to build his own business empire. This photograph of James W. Ellsworth as a young man was taken in Chicago.

Eva Frances Butler, daughter of a Chicago paper manufacturer, became Mrs. James W. Ellsworth on November 5, 1874. They had a son, Linn (later called Lincoln), and a daughter, Clare. Eva died of pneumonia in 1888. After her death, James brought his two children back to Hudson, where he built a home and named it Evamere in honor of his wife.

Lincoln Ellsworth was James and Eva's first child, born May 12, 1880, in Chicago. As a very young man, he changed his name to Lincoln. He wrote that he never felt very close to his father. In May of 1925, he teamed up with Norwegian Roald Amundsen and Umberto Nobile to explore regions near the North Pole in the dirigible *Norge*. With much reservation, James W. Ellsworth funded the expedition. Lincoln and the other explorers were lost in the vast snowy arctic at the time of James' death. Lincoln emerged safely to learn that James had died of pneumonia. Lincoln continued with his adventures and was honored with a commemorative postage stamp. He died in 1951.

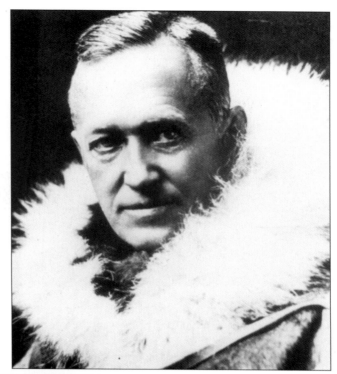

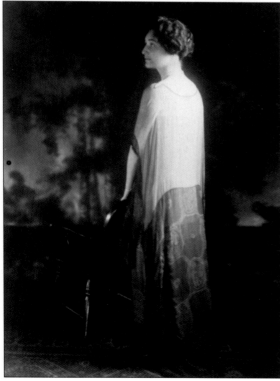

James and Eva's daughter, Clare, was born in Chicago on November 5, 1884. By accounts, she was a lively girl raised with privilege, surrounded by James's art and antique collection, and exposed to such greats as Paderewski. She married Bernon S. Prentice and had a daughter, Clare, and son, Stephen. When her father died, she inherited half of his wealth; the other half went to her brother, Lincoln. She died in 1930.

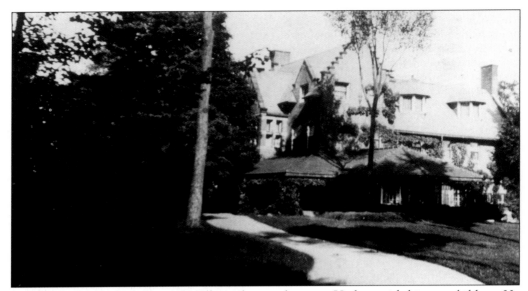

After his wife Eva died, James W. Ellsworth came home to Hudson with his two children. He settled them in with their grandmother on the old Ellsworth family farm, and began renovating it. It became a country estate; the mansion, manicured lawns, and elm trees were surrounded by a brick and stone wall. He named it Evamere in honor of his wife. It was torn down in 1951.

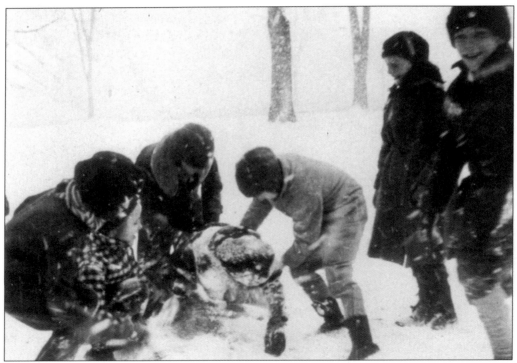

The children in this image are probably Lincoln, Clare, and their cousins, Ruby and Henry. The latter two were James Ellsworth's brother Henry's children. The children are playing in the snow on the Evamere's grounds.

Mrs. Julia Clark Fincke married James W. Ellsworth in 1895. Theirs was a long and happy companionship of 25 years. The second Mrs. Ellsworth is said to have had "great charm and poise," and was deft in humoring her sometimes demanding and high-strung husband.

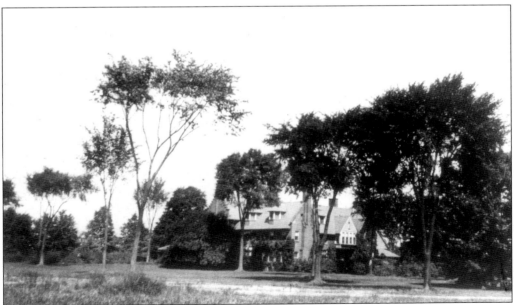

Evamere served as a summer home for James W. Ellsworth. It was filled with art and antiques. There was a large lake on the property. He was meticulous about the lawns, trees and shrubs. Harry Cooper was the highly skilled groundskeeper.

Julia Ellsworth posed for this photograph taken at Evamere.

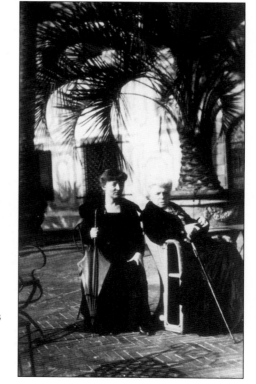

Mrs. Luella C. Dodds (left) was James Ellsworth's friend and assistant. She is pictured here with Julia Ellsworth at their Florence home, Villa Palmieri. Mrs. Ellsworth died on November 3, 1921.

This is a photograph of the clock tower at Evamere.

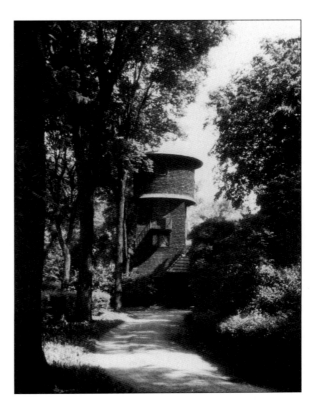

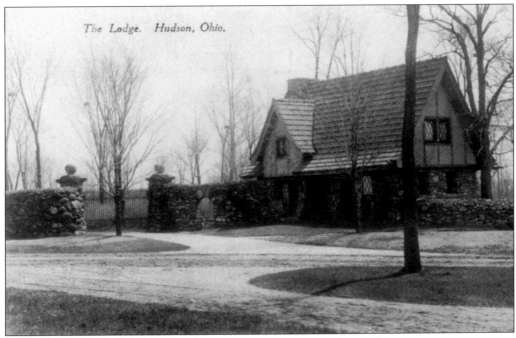

All that is left of Evamere, Ellsworth's magnificent estate, is the gatehouse.

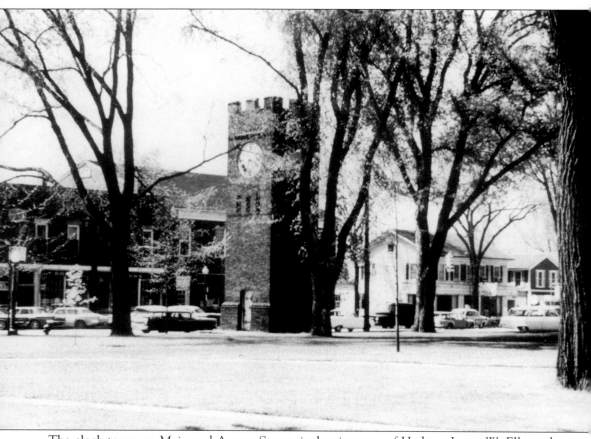

The clock tower on Main and Aurora Streets is the signature of Hudson. James W. Ellsworth built it in 1912 as a gift to the town.

Eight
CHANGES

Henry Noble Day (1808–1890) was a professor of sacred rhetoric at Western Reserve College and active in raising funds to bring the Cleveland and Pittsburgh Railroad to Hudson. In 1849, Day built Hudson's Pentagon building on the corner of College and Aurora Streets, at a cost of $18,000. The 5-sided, 3-story brick building stood between the Straight & Son Cheese Storehouse (now Hayden Hall) and the Congregational Church. It was built as a pentagon due to the shape of the lot. The building filled with businesses, including a publishing company, the college's newspaper, and retail stores.

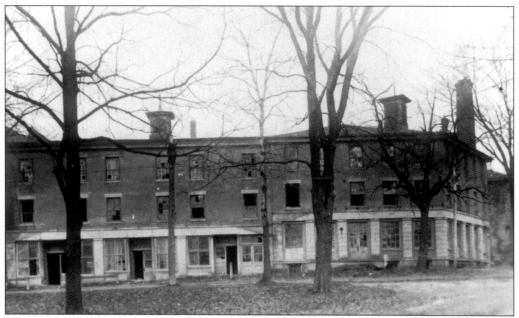

One by one, the businesses in the Pentagon failed. They had all been founded on credit and the country was headed into recession. Seymour Straight, owner of the cheese house next door, bought the building for $7,000 in 1867 for office space. By the early 1900s, it was in major disrepair.

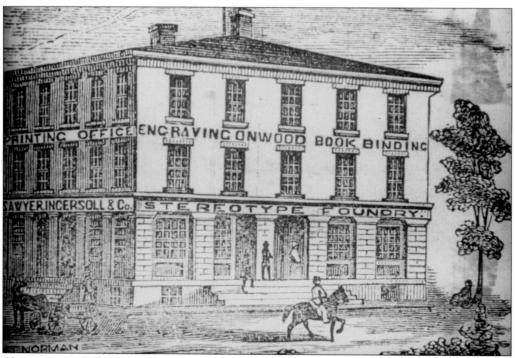

This is a period illustration of the Pentagon Building when it was bustling with business. The artist's name, in the lower left-hand corner, looks like W.T. Norman.

Seymour Straight built this brick warehouse in 1878 to store cheese and butter. Costing $10,000 to build, it had steam elevators and a ventilating system that ran from the foot of College Street through one thousand feet of tile to the warehouse basement and up through the cupola. Fans and pipes that ran from the icehouse behind it kept the cheeses and butter cool. During hard times, Straight and Son was one of the biggest employers in town. Offices were next door in the Pentagon. The building has seen several uses since, including a feed mill, a restaurant, and the Hudson Country Day School. It now belongs to the Western Reserve Academy and is named Hayden Hall.

When James W. Ellsworth returned to Hudson in 1907, he had the Pentagon Building torn down. In its place, Ellsworth built the parsonage for the Congregational Church.

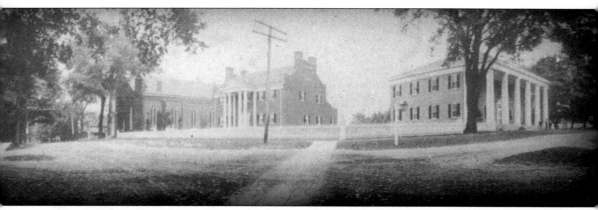

This is a scene along Aurora Street. At left is the Congregational Church. James W. Ellsworth razed the old Pentagon and in its place built the Parsonage (center) in 1908 as a gift to the church. Ellsworth also remodeled the cheese factory (right) to be used as a clubhouse (now Hayden Hall).

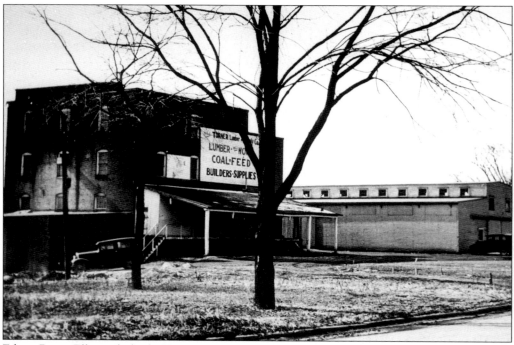

Edgar Birge Ellsworth built Turner's Mill in 1852. Ellsworth and Henry Noble Day were members of a consortium that started the Hudson Planing and Lumber Company. In 1873, Jacob Miner acquired the building and turned it into a grain mill. It put out 50 barrels a day during that time. Ernest Fillius was next to operate the mill in 1891. *Perfection, Crown,* and *Crystal* flours came from this mill.

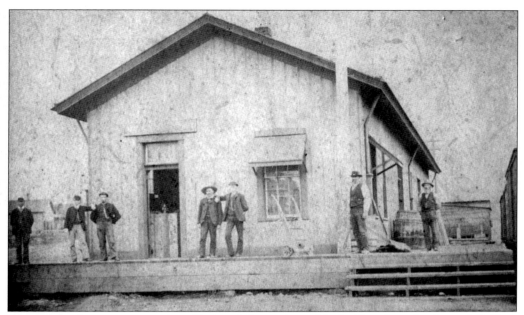

The freight depot once stood on Railroad Street (now Maple Drive) at the foot of College Street. On February 21, 1861, a train carrying Abraham Lincoln stopped at the station on its way from Cleveland to Pittsburgh. Hudson residents got a brief glimpse of the president. The back of the photograph names six of the seven men, but not in order. They were Harrs Olsen, Ed Bosworth, Earl Johnson, Lissk Cumsine, William Meloy, and M. Deady.

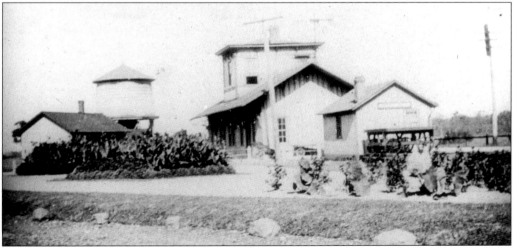

This is an image of the old passenger depot built on West Streetsboro Road. The Cleveland and Pittsburgh Railroad rolled into Hudson in the winter of 1851–1852, bringing great prosperity. A link between Akron and Hudson was added. Then came the Clinton Line Railroad, which was to run from Hudson to the Pennsylvania state line. With Henry Noble Day and Judge Van Rensslaer Humphey as president and principal trustee, respectively, the people of Hudson were behind it with their money and their land. But in 1856, the economy shifted, and the Clinton construction costs far exceeded estimates. It took many years for Hudson to recover from this costly calamity.

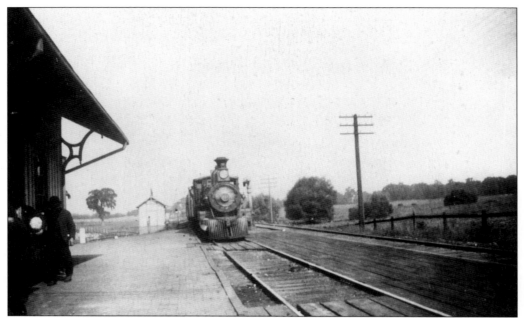

A train pulled into Hudson's old Peninsula Road (now West Streetsboro Road) depot. Steam engines posed a hazard to train passengers in the summer. Dirt, smoke, and cinders flew back into the open windows of the passenger cars, making for an unpleasant ride. In the winter a pot-bellied stove heated the depot, and waiting passengers gathered around it for warmth and conversation.

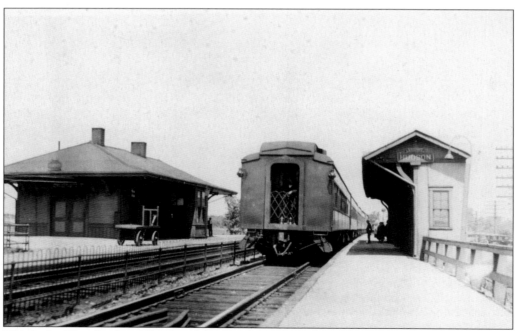

This is the Cleveland and Pittsburgh Railroad passenger depot built near the West Streetsboro Road overpass.

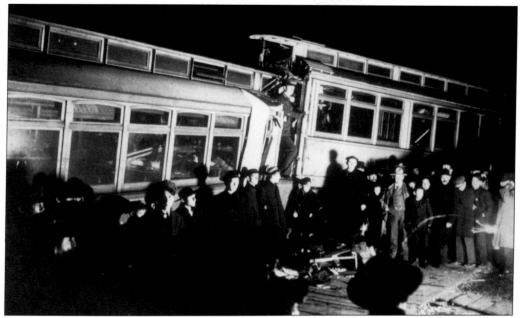

This is a night scene at one of the passenger depots.

This undated photograph is labeled simply "Old Settlers at Home Day." Home Day began in 1906 in an effort to renew Hudson's civic pride after the setbacks it suffered at the end of the 19th century.

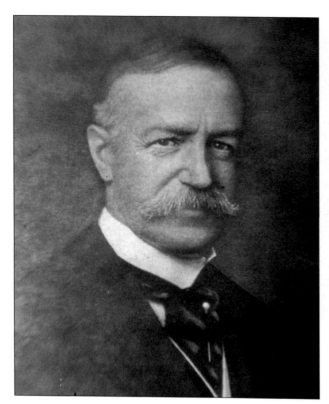

James W. Ellsworth (1849–1925) made his money in coal, banking, and railroading, among other business pursuits. When he returned to Hudson from Chicago after the death of his wife, Eva, he learned that the town had lost businesses and population and decided to turn it into a "model town." He made funds available for street paving, underground telephone wires, and a sewer system. He established a secure banking system, and, in 1916, started the Western Reserve Academy.

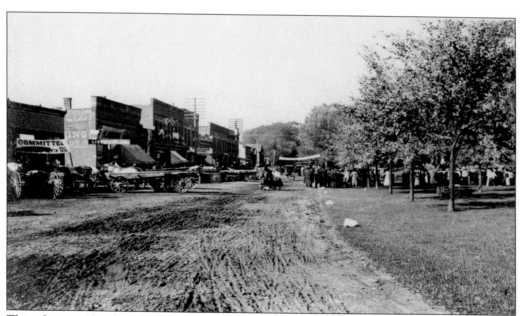

This photograph of North Main Street was taken in 1906 or 1907 during the Home Day celebration. A *Welcome Home* banner can be seen between the third and fourth buildings.

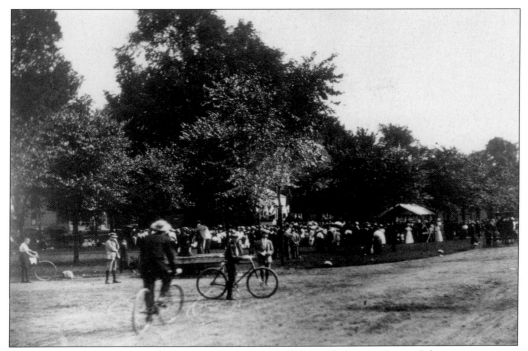

The camera glimpses the village green during one of the early Home Day celebrations.

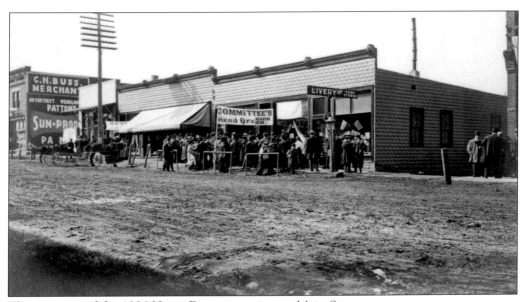

This is a view of the 1906 Home Day registration on Main Street.

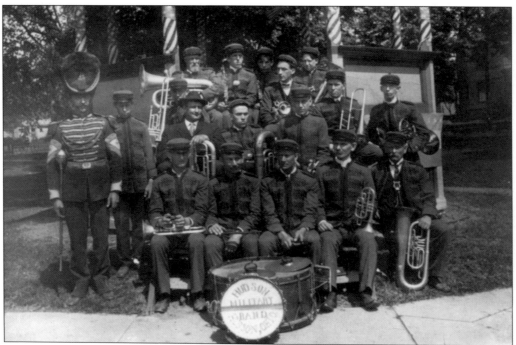

Pictured here is the Hudson Military Band.

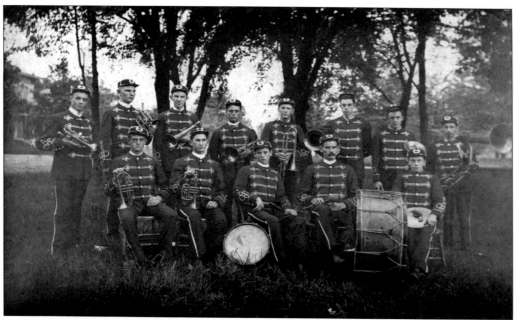

In the late 1880s or early 1890s, the Hudson Band posed for this picture. Seated from left to right are William Ahern, John Osborn, Tom Whapham, E.W. Seymour, and Edwin Palmer. Only six of the musicians in the back row are identified. They are: Fred Whapham, Fred Sprague, Charles Morrill, Dick Whapham, George Lockhart, and Charles Whapham.

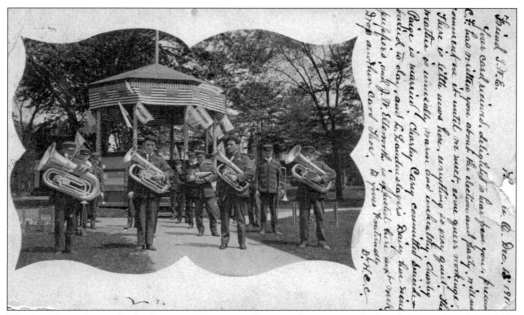

The bandstand was decked out in American flags in this postcard, dated December 13, 1911, and addressed to T.W. Elliman in Kissimmee, Florida.

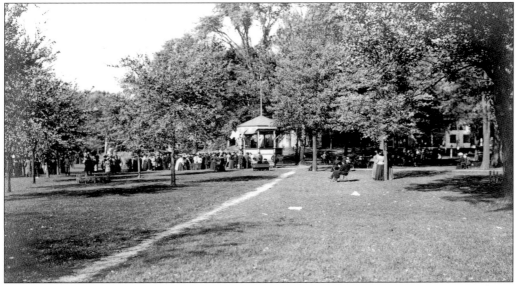

The Green filled with people during the Home Day celebration of 1906. The bandstand was used for speeches.

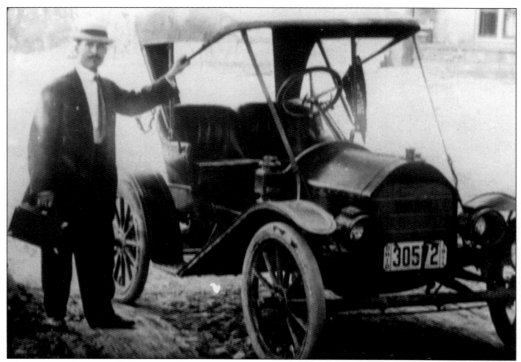

The automobile rapidly changed Hudson's way of life. Homemakers had been accustomed to the bakery wagon and the tea wagon that brought coffee, tea, breads, and spices to their doors. With the advent of the automobile, home deliveries became a thing of the past. The first Model Ts came to Hudson in 1911. They drove over cinder, clay, and muddy roads. Driver's licenses were not required until 1937. If one of these new automobiles became stuck, a horse and wagon were needed to pull them out. Frederick Sprague was a resourceful resident who built a wooden turntable in his garage, because his automobile was so hard to back up. His car finally blew up on him.

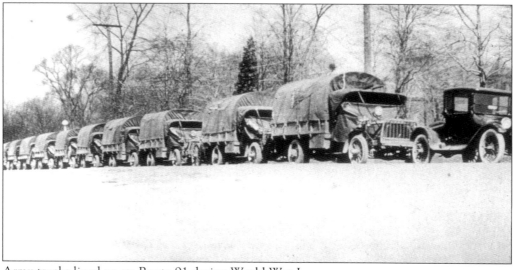

Army trucks lined up on Route 91 during World War I.

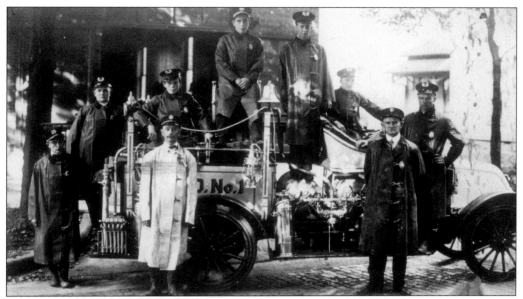

Hudson Fire Truck No. 1 was the first motorized piece of fire-fighting equipment in town. It was probably the Seagrave truck purchased in the 1920s. The company poses with it, but none of the fire fighters are identified. One of them may be Chief John Kohl.

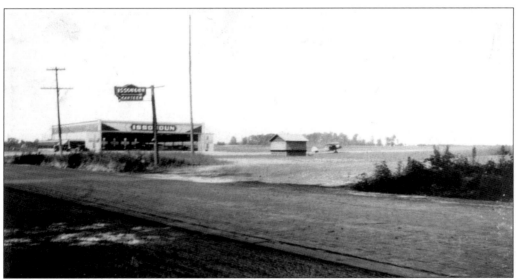

Before the hangar was built in 1927, airplanes landed at the Mid City Airport at Darrowville in Hudson Township. This photograph was taken in about 1930. Once a flat wheat field, the runways were planned by World War I veteran flyers Colonel Henry Breckinridge and Major Thomas G. Lanphier. Breckinridge was the Assistant Secretary of War under President Woodrow Wilson. Lanphier was the commander of the Issoudun airfield in France and the leader of the first Air Corps pursuit group. The airport was originally named for the French field, but later became known as Mid City. The two expected to see their airport become a commercial success, and perhaps even a transcontinental air facility. Their plans collapsed when the Depression hit. It was rumored that Charles Lindbergh, a friend of the two, secretly flew into Mid City.

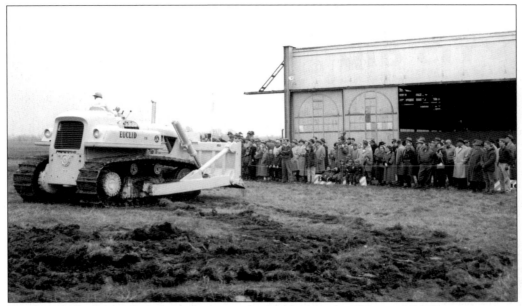

Four hundred pilots and student pilots were displaced when the 223-acre Mid City Airport was closed down to make way for the General Motors Corporation's Euclid Division plant, known as Terex. The plant made huge earthmoving equipment such as the bulldozer pictured above. Here, a crowd looks on during the Euclid plant's groundbreaking. The airport hangar is at right.

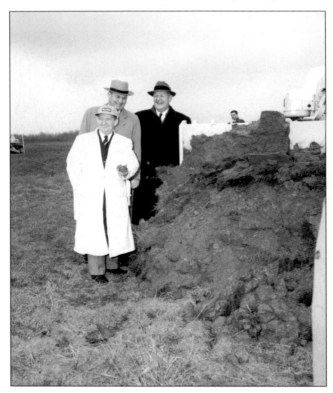

Ohio Governor C. William O'Neil (front) took part in the groundbreaking of GM's Euclid Division plant on March 27, 1957. The plant would be one of Northeast Ohio's most important industrial developments. The two men with the governor in the photograph were probably GM executives.

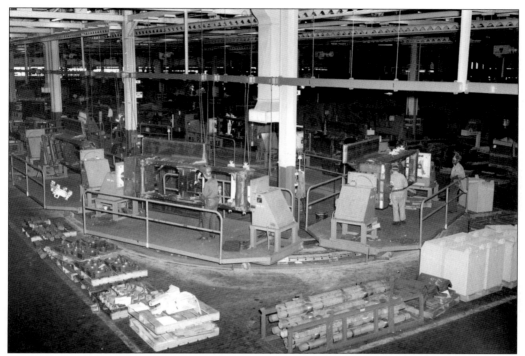

Building the Euclid/Terex Plant meant widening Darrow Road and subsequently losing homes and businesses. This shows men working inside the Euclid Plant.

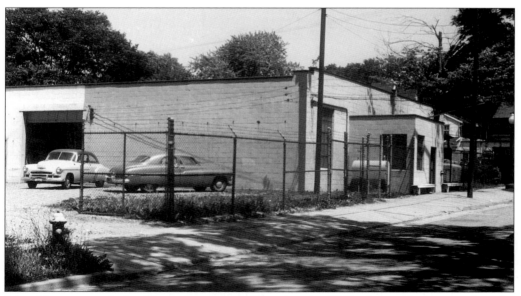

John Morse started the Morse Instrument Company in 1941. An avid photographer, he invented an aerial gun camera during the war. It was used to verify a kill. Later, he developed nautical instruments and location devices. This photograph of the Morse Instrument Company was taken in 1950. The company became Morse Controls and merged with Rockwell International in 1969. The structure itself was built in 1922 as a garage.

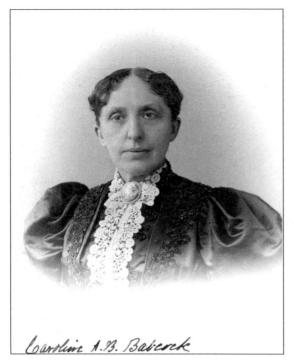

Caroline A. B. Babcock

After Caroline Baldwin Babcock's husband Perry died, she moved back to Hudson from Cleveland. She was responsible for founding the Hudson Library in 1910. James W. Ellsworth assisted her by offering the Club House, built in 1878 (now Hayden Hall on College Street), to house the books. Because she had great respect for her heritage and the town's history, she expressed the hope that one day the library might be located in one of Hudson's old homes.

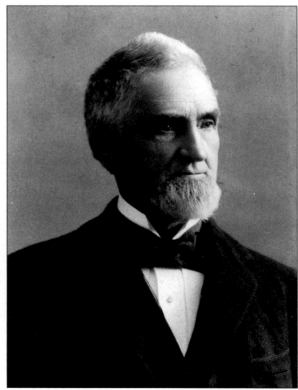

Perry H. Babcock was Caroline Baldwin Babcock's husband. He was a wealthy businessman from Cleveland.

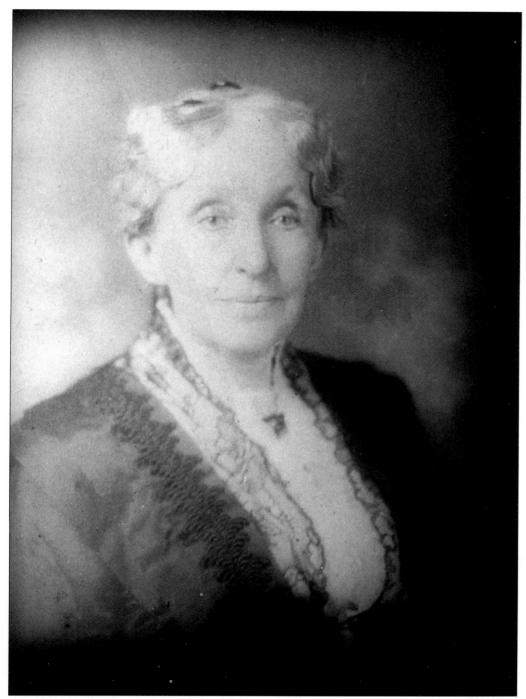

When Caroline Baldwin Babcock died in 1921, she left money in trust for the library. Part of that legacy went toward buying and renovating the home at 22 Aurora Street, where she was born. The building then became home to the Hudson Library and Historical Society.

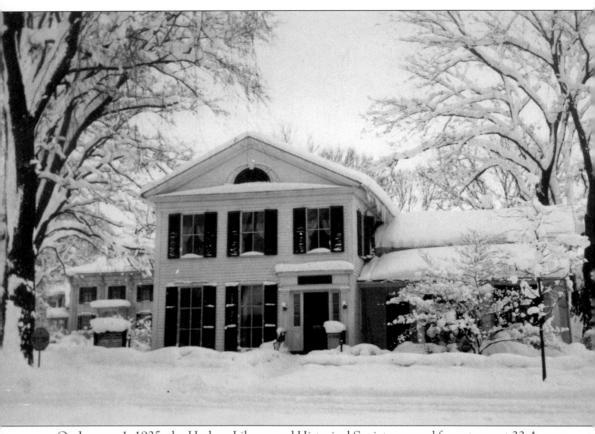

On January 1, 1925, the Hudson Library and Historical Society opened for patrons at 22 Aurora Street. Additions have since been made to accommodate the growing collection. This photograph was taken c. 1950 after a heavy snow. All the images in this book have been generously shared by the Hudson Library and Historical Society.